Drawing and Painting the Undead

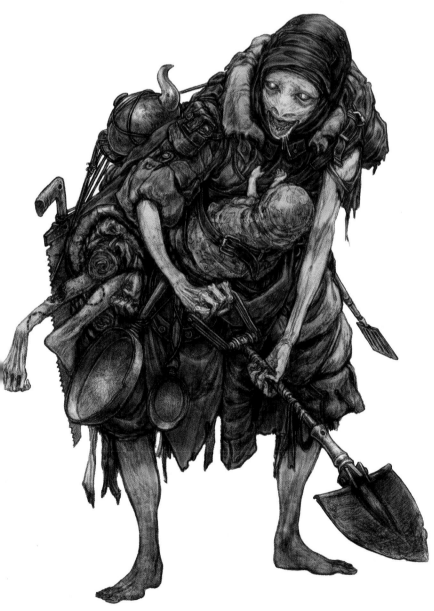

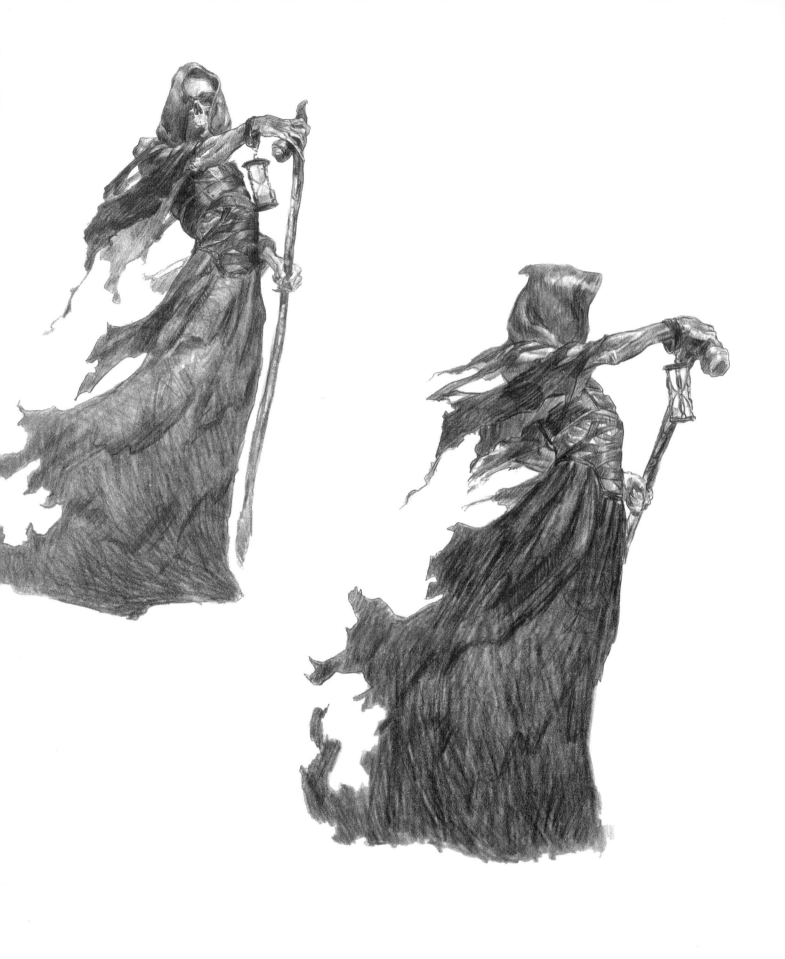

Drawing and Painting the Undead

Keith Thompson

BARRON'S

A QUARTO BOOK

Copyright © 2008 Quarto Inc.

First edition for the United States and Canada published in 2008 by Barron's Educational Series, Inc.

All inquiries should be addressed to:
Barron's Educational Series, Inc.
250 Wireless Boulevard
Hauppauge, NY 11788
www.barronseduc.com

ISBN-13: 978-0-7641-3813-3
ISBN-10: 0-7641-3813-8

Library of Congress Control Number: 2007921332

QUAR.FGG

Conceived, designed, and produced by
Quarto Publishing plc
The Old Brewery
6 Blundell Street
London N7 9BH

Project editor: **Anna Amari-Parker**
Art editor: **Julie Joubinaux**
Designer: **Paul Griffin**
Copy editor: **Anna Amari-Parker**
Author's assistant: **Jo-Anne Rioux**
Art director: **Caroline Guest**
Picture researcher: **Claudia Tate**
Proofreader: **Susannah Wight**
Indexer: **Diana Le Core**

Creative director: **Moira Clinch**
Publisher: **Paul Carslake**

Manufactured by Provision (PTE) Ltd., Singapore
Printed in China by 1010 Printing International Ltd.

9 8 7 6 5 4 3 2 1

Contents

THE CATACOMBS

Foreword

Since the dawn of time, civilizations have cultivated the idea of undead creatures who, having pierced the veil of death, still walk among the living. Everyone knows what a "ghost" is yet the universal acceptance of the undead within the psyche of different cultures has been colored by time, history, and place.

Medieval personifications of famine and pestilence in the Middle Ages, for example, were images of the Grim Reaper. In the Victorian age, many of the spiritual entities haunting ancestral homes were conceived as a direct response to that period's rationalism. The modern-day zombie reflects society's continuous unease with scientific programs of genetic engineering.

This book combines the fundamentals of graphic art and the principles of good design in showing you how to create great macabre illustrations.

About This Book

Everything you need to know to create great ghoulish graphic art is contained here. The first section walks you through materials and core techniques, and looks at aspects of picture-making, such as composition and lighting. The heart of the book is the Catacombs section, which presents 30 macabre portraits of different undead creatures and looks at how to recreate them.

Getting Started
(pages 8–55)

Filled with practical advice for creating all kinds of terrifying characters, this section contains lessons aimed at those wanting to explore this specialist field, as well as information about tools and techniques you may wish to bring to your work. In addition, much of the information is general enough to be used for any kind of figure.

How the pros do it
See how professional artists create their art, from conceptualization to finished piece.

The Catacombs
(pages 56–125)

This spine-chilling directory introduces the reader to a range of undead abominations, organized into three different thematic categories: the Half-Life, the Walking Dead, and the Ethereal. The technical step-by-step processes involved in developing each illustration, from initial concept to final artwork, are explained in detail. You can either recreate the characters shown or use this information as a springboard for your own art.

Recreate this...
Practical information for recreating the creature.

Thumbnails
Exploratory sketches analyze the artist's earliest workings and ideas.

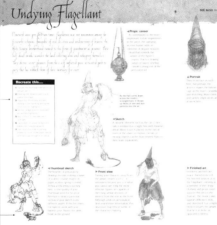

Defining features
Where appropriate, defining features, such as props or costume, are analyzed in detail.

Rotations
Many of the creatures are shown from different views to illustrate how the artist has fully realized his or her creation.

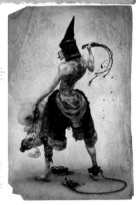

Background story
Where applicable, an explanation of the creature's origin is given.

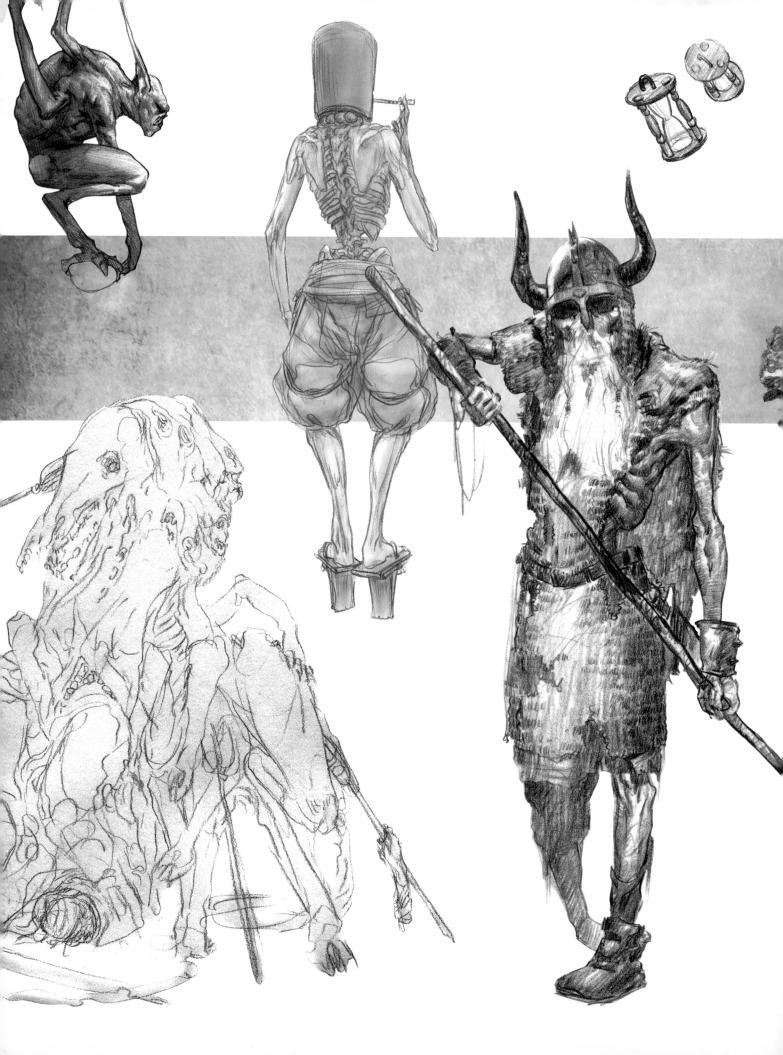

Getting Started

The *undead* is a collective term for beings that are deceased yet behave as if alive. They feature in legends and works of fiction, especially fantasy and horror. These creatures may be disembodied spirits, such as ghosts or wraiths, or corporeal entities, such as vampires, skeletons, and zombies. This section will advise you on the best tools for your craft and how to set up your personal workstation, and will teach you the value of keeping a sketchbook full of inspirational ideas. Your creatures are, after all, the sum total of what inspires and interests you expressed on paper.

Showcase of Horrors

This diabolical compilation conveys the magical pull of great undead art. It should terrify the senses, curdle the blood, make the spine tingle, and cause teeth to chatter with its powerful creations, eery dimensions, and atmospheric subworlds.

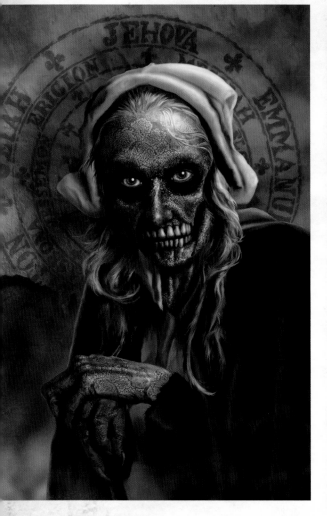

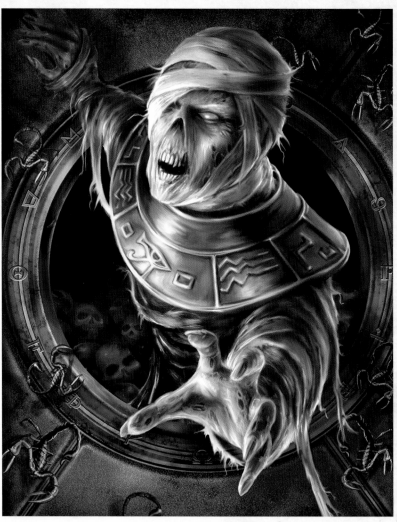

▲ From Salem

Artist: Malcolm Brown

Seventeenth-century Puritanical society wore a secret face, darkly venomous and deeply superstitious. The old crone with her dead eyes and reptilian skin is a chilling embodiment of the cruelties, hypocrisies, and prejudices that sparked the witch-frenzy massacres of Europe and New England from 1500 to 1650.

▲ The mummy

Artist: Anne Stokes

Reaching out across the boundaries of time and matter, the essence of the Egyptian mummy is indestructible and lives on, ready to be reawakened. Having drunk the elixir of life, this great pharaoh is doomed to wander the planes of existence forever, desperate to quell the hungers that burn in his immortal soul.

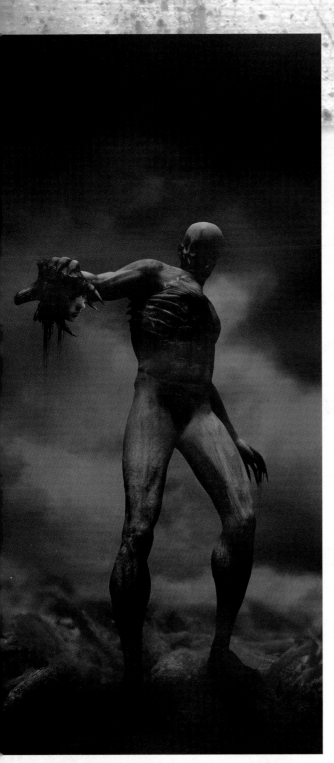

▲ Killer
Artist: Paul Gerrard

In a scorched wasteland, a strange invader arrives, newborn and deadly. This bitter offspring of the soil is cast in the image of the destructor (man) and sprung from the earth's own desertified clods. The land, raped and pillaged for long enough, has produced a killer who will wreak revenge on the human race, hunting down every last man, woman, and child.

▼ Spark of life
Artist: Paul Gerrard

These primeval creatures are conjoined in an ancient symbiosis with the surrounding swamplands. Although the marshes have long been polluted and abused, these archaic beings have grasped the essence of life within their core because the survival of the land depends on it. If they die, this landscape dies with them. These native inhabitants have no energy left over for themselves, only enough to sustain the earth.

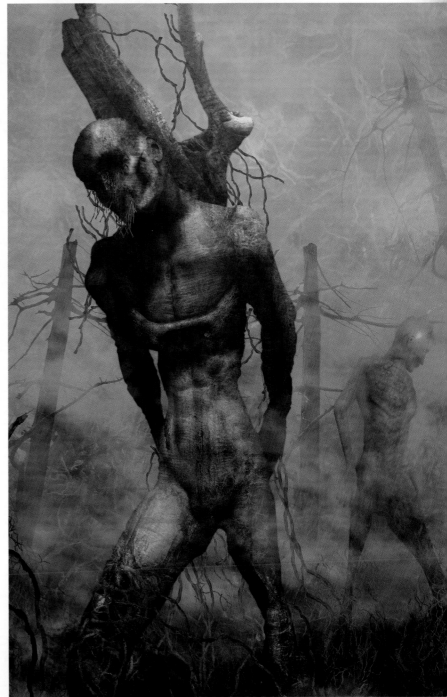

Inspiration

Striking macabre art does not originate in a vacuum but takes on shape, color, and importance through different sources and areas of interest. A rich visual reference library is indispensable to any artist.

Traditional sources

Aside from the monsters under your bed, and the vampires and ghosts that lurk in the shadows, horror is essentially about fear. The ancients feared what they could not understand: events in the natural world, death, and disease. Our society fears what it cannot control—whether it be terrorism, biohazards, or the cannibal next door. Spend time exploring both traditional and contemporary sources to identify the concepts that intrigue, fascinate, or scare you.

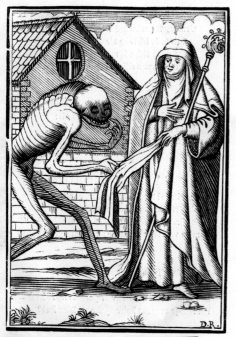

◄ **Grim etchings**
Death makes a sheepish appearance before the abbess in *The Dance of Death* (1843).

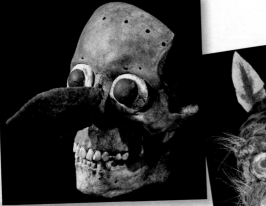 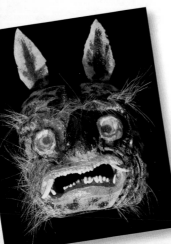

▲ ► **Communicating with the dead**
Ritual Aztec (above) and Mexican (right) masks used by shamans for conversing with spirits beyond the grave.

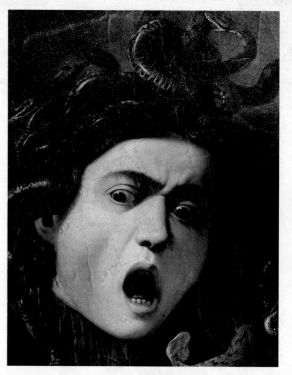

▲ **Mythological monsters**
Caravaggio's *Medusa* (1598–9) captures the dramatic stare of the gorgon and her writhing, hissing, snake-hair.

Classical sources

The mythologies of the ancient world offer a wealth of images, such as the snake-haired Medusa and Cerberus, the hellish three-headed mastiff, as well as memorable personifications of war, disease, or fear.

Anatomy and art

Throughout history, the human body has fascinated artists even though anatomical study and medicine were at one time considered arcane practices. In recent years, the German anatomist Günther von Hagen has presented his highly successful traveling *Body Worlds* exhibition of preserved human bodies and body parts using a technique called plastination to reveal inner anatomical structures.

European culture and beyond

The budding illustrator will find depictions of the Grim Reaper from the Middle Ages onward to be of interest. However, don't limit yourself to Eurocentric sources. Mesoamerican and African traditions, with their bizarre and bloodthirsty gods, make excellent research material. Although more ethereal, Oriental art is filled with elegant and elusive ghosts and spirits.

Nature morte

This style of art, which means "dead nature" or "still life," contains excellent studies of lifeless objects or items that are "in repose," such as skulls, bones, and dead fauna and flora.

Anatomical observation

The study of anatomy gives you a good understanding of what is normal as opposed to pathological. A sound biological foundation will support the appearance, function, and nature of any terrifying creation. For example, when considering bringing to life a character who perspires bile, communicating the link between liver infection and the gall bladder through greenish-yellow hues will add realism to your work.

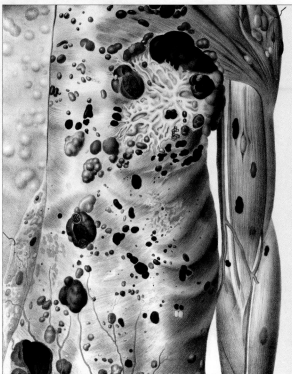

▶ Pathological anatomy
This nineteenth-century engraving shows an assortment of cancerous tumors on the chest of a patient.

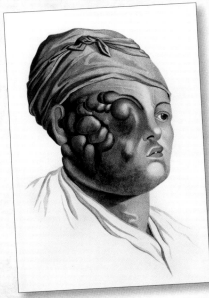

▲ Skin diseases
A nineteenth-century engraving of a skin affliction known as King's Evil or scrofula, which affects the lymph glands of the neck.

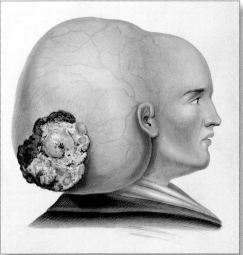

◀ Brain infections
This nineteenth-century engraving depicts the occurrence of a severe form of fungal infection affecting the dura mater of the brain.

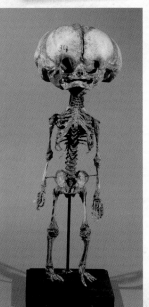

◀ Medical specimens
The enlarged, swollen skull of this hydrocephalic fetus points to an excessive amount of water in the brain, but visually looks like an alien from outer space.

The sight of blood

Consulting medical textbooks or watching surgical procedures on TV will give you insight into the human body as it's rarely seen. If you want to use blood to good effect, you will need to understand its overpowering intensity. Also make sure you have a good understanding of the body's internal workings before attempting to feature this in your work. Our simplified conception of organs as mere outlines is a far cry from what they really look like once the flesh is removed.

Contemporary sources

Today's comics, films, books, and computer games are recognized treasure troves of material. Some will directly inspire your work, others will simply remain your personal favorites.

► **Comic books and graphic novels**
Japanese comics such as *Gyo* by Junji Ito (top), *Berserk* by Kentaro Miura (middle), *Blame!* by Tsutomu Nihei (bottom), *Uzumaki* by Junji Ito, and *Hellboy* by Mike Mignola are publications worth leafing through for ideas.

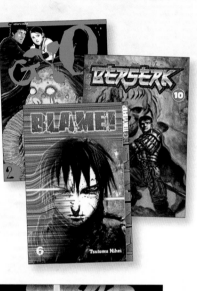

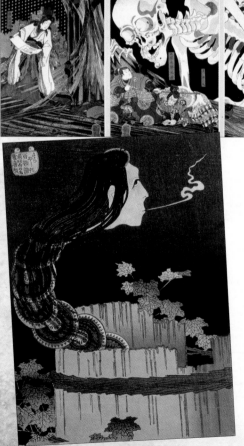

◄ ▲ **Vintage and "new" frights**
The horror genre is still thriving and has come a long way since its humble and silent origins. Scenes from *Captain Kronos: Vampire Hunter* (1974) (above), *Evil Dead 2* (1987) (middle), and *28 Days Later* (2002) (below).

◄ ▼ **Gorefest flicks**
Any aspiring creator of undead designs should definitely press freezeframe on classic horror moments from *Night of the Living Dead* (1990) (left) and *Brain Dead* (1989) (below) for gruesome ideas.

◄ ▲ **Japanese woodblocks and colored prints**
These eighteenth-century woodcut prints featuring a samurai confronting a specter (above) and a well ghost (left) testify to the strong interest of the Japanese in supernatural elements.

Personal interests

There may be a specific entertainment or cultural niche that you find particularly inspiring. Such personalized sources are useful because they will contain more obscure references worth plundering. The less well known an influence, the more striking your work will be.

Graphic action games

Well-known survival horror video games are bursting with good ideas as they contain some of the most imaginative, disturbing, and memorable creatures ever seen. Check out: *System Shock 2*, *Silent Hill*, *Silent Hill 2*, *Resident Evil 2*, *Resident Evil 4*, *Vampire: Bloodlines*, *The Suffering*, *Devil May Cry*, and *Devil May Cry 3*.

◀ **Video-game creature development**
This exploratory sketch of a mummified husk by Climax was first presented in Konami's *Silent Hill Origins*.

▲ **Video game still from Silent Hill Origins**
Truck driver Travis O'Grady faces his innermost fears as he enters the smoke-shrouded town of Silent Hill after becoming stranded during a seemingly routine delivery.

▶ **Bubble-head nurse from Silent Hill 2**
One of the many residents to haunt the town, these nightmarish figures hunt in packs and brandish long kitchen knives. The video gamer enjoys a dark, macabre element largely from the disturbing background noises and the innovative use of flesh in many of the adversaries.

Books

Horror fiction vocalizes and dramatizes society's most hidden fears and desires. Its dark apocalyptic visions of a world ravaged by sinister forces, spooky Victorian literature, and spine-tingling Gothic novels of murder, deceit, and supernatural hauntings make electrifying reading.

▲ **Suspenseful fiction**
Mary Shelley's *Frankenstein* (1817), Richard Matheson's *I am Legend* (1954), and *The Call of Cthulhu and Other Weird Tales* (1928) by H.P. Lovecraft are prime examples of fictionalized literary horror.

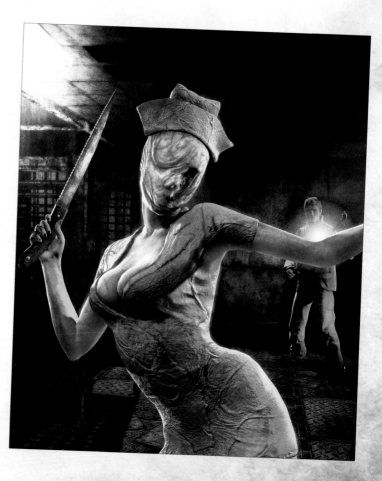

Working Traditionally

This section shows you how to set up a professional workstation for producing great visual art from scratch. It lists the tools of the trade and examines the required equipment—anything from drawing pencils to computer desktops.

Traditional media possess an inherent advantage over their digital counterparts: visual complexity. The algorithms involved in imitating pencil linework on a computer screen cannot yet come close to the complexity of pencil lines on paper (eventually this will be overcome). In scanning a traditional image, some of the complexity may be lost. Certain tasks (masking, for example) present no material advantages in traditional procedures and should be relegated solely to the digital process. Traditional and digital media should be recognized as noncompetitive elements serving differing roles, and matching the needs of the artist. Traditional linework, more so than digital lines, may be more appealing to the artist whose main concerns are smooth workflow and spontaneity.

▶ Basic tools
Regular pencils come in traditional and mechanical versions (with their corresponding pencil leads).

Traditional workspace tools

Blue col-erase pencils
The tools of choice for committed animators, blue col-erase pencils are erasable colored pencils. Distinct from graphite, they are far less disposed to smudging and smearing. When scanned, their color can be desaturated and resaturated in whatever hues the artist desires. A wide range of colors is available, but different binders and pigments can result in a noticeably varying softness and feel to the pencil. Experiment using these tools, bearing in mind that the actual color of the pencil is unimportant.

Pencil extender
Get more use out of short pencils with this useful tool. Avoid using a pencil lengthener, however, for sweeping, gestural drawing, as its balance and ergonomics leave something to be desired.

Erasers and refills
Relatively standard white eraser refills are made both for normal holders and for electric erasers. The regular holder can be useful for immediate and precise erasing, but make sure that the tip is clean to avoid smudging. Check any eraser before buying because the quality can vary widely. Good-quality eraser sticks tend to be whiter and softer than their extremely poor, harder, and yellower counterparts. The electric eraser spins the tip of the eraser and is an extremely fast and efficient way of erasing heavy pencilwork, while still being gentle to the surface of the paper.

1　　**2**　　**3**　　**4**　　**5**

◀ ▲ Different kinds of erasers
Discover your personal favorite among the many types that are available on the market.
1 Eraser in a holder
2 Beveled eraser in holder
3 Standard eraser
4 Gum eraser
5 Kneaded eraser

▲ Using a pencil lengthener
Use this sliding-grip holder to give short, stubby pencils a longer lease of life.

Choosing your paper

Experiment with the different kinds of drawing paper that are available to the artist today. Find out if you prefer a smoother or rougher texture. Your choice of paper should be heavy and sturdy enough to handle repeated drawing and erasing.

Choosing your sharpener

While certain pencil tips (soft-edged) are better sharpened with a craft knife, a good-quality electric sharpener is extremely useful for general sharpening (especially in batches). Make sure it is of the helical variety and not simply a rotating blade.

Choosing your drawing surface

Experiment with using different types of board to find the drawing surface that suits you best, one that is rigid enough not to bend.

▶ **Types of drawing paper**
1 Textured, handmade paper
2 Smooth white paper
3 Watercolor paper
4 Toned paper

Time-saving hints

These handy tips could save you time better spent on creating actual artwork than on executing the craft's tedious tasks.

• Have different kinds of pencils sharpened beforehand. While it only takes a moment to sharpen a pencil point, this small interruption can break your artistic momentum.

• Mount your artwork onto a masonite board. This gives you a hard surface to work on and, if you want to shift locations, avoids damaging the paper.

• Some artists hate categorizing things and cleaning up areas of high activity. However, a simple, well-designed system can help create a balance between structure and spontaneity. Without it, you're eventually going to lose something, or need to hunt for something while working on your art.

▲ **Automatic sharpener**
If you find using an electric or traditional sharpener unsatisfactory, touch up the end of your pencil with an emery board.

▼ **Base of operations**
Choose a drawing base that suits the weight of pressure you apply to your pencil. Wood or plastic may be too hard.

Setting up your workstation

When working traditionally, the position of your light source is key. You will want bright light coming in through your window from about a 10 o'clock position if you are right-handed (if you are left-handed, from a 2 o'clock position). This will minimize cast shadows falling over your work.

The larger and cleaner the work surface, the better. Have everything prepared and within reach without any clutter.

If using paints, or anything that gives off poisonous fumes, make sure you work in a well-ventilated area.

Working Digitally

When working onscreen, it is a good idea to proceed in batches. If you are working on several projects at once, leave tasks to be done collectively.

Scanning a series of drawings altogether saves time compared with setting up each piece of art individually. For more manual tasks, such as digitally cleaning up the scans, it can save time if the work is done in a series.

Organizing electronic files

Keep digital computer files alphabetically ordered. Remember to keep zero as a placeholder for numbering systems in a series that go up to at least double digits (11.jpg, for example, will be listed higher than 1.jpg, but not 01.jpg).

▲ **Efficient filekeeping**
Keeping your work neatly named and numbered in a logical manner can spare you the nightmare of having to later sift through folder upon folder of misnamed or unidentified files.

▲ **Monitors**
Computers depreciate rapidly in value but a good monitor will be just as valuable as the day you bought it. A multimonitor arrangement is an excellent way of expanding your workstation and is surprisingly easy to set up.

Setting up a digital workstation

When working digitally, having a light on in the room and not shining on the monitor helps to reduce eye strain. Screen glare and unwanted reflections dramatically reduce your ability to see subtleties onscreen. If working for extended periods of time, remember to take breaks. Venture outside to view objects at varying distances, otherwise your eyes may become strained, resulting in problems focusing and headaches.

Choosing the right chair can also be extremely important. Be sure you do not work hunched over; back problems or even compression of the lower organs can develop as a result. Repetitive strain injury can be avoided by regularly switching from the tablet to the mouse as you work. Switch projects intermittently if repetitive processes are required.

Digital tools of the trade

Scanner

Avoid scanners that are thin or advertise speed as a prime feature. The heavier the scanner, the thicker its glass plate, which improves scanning quality. Be sure the light is off when not in use as this can save wear on the bulb and preserve scan quality. (There are bulb-saving features that automatically turn off the scanner, but these can be unreliable.) It is a good idea to unplug the power from the scanner when it is not in use. This means that the scanner will need to warm up once switched on again, but the increase in longevity is worth it. Although you may want to scan strange materials for use in art (wood, painted textures), be careful you don't scratch or mark the glass surface of the scanner.

Tablet

Although there is still much to be improved upon in terms of technology, the tablet is a necessary tool for working digitally. Experiment with tablet sizes, but because a degree of visual disconnection will always be present, a larger tablet might not be worth its ungainly size or the impediment of having to use the keyboard and mouse in conjunction with the tablet. On multimonitor set-ups, make sure that the tablet is designated to work only on the primary monitor. Use a mouse to access secondary displays.

◀ Scanner

The gateway between traditional and digital. Be careful that the quality of your sketches is not diminished in the scanning.

Tablet PC

These may be seen as an alternative to desktop PCs, or as an accompaniment to your main workstation. Although this model has no pressure sensitivity, being able to draw directly onscreen has its advantages (especially for tedious tasks, such as masking an image). With a wireless network, all art files can be kept in a shared file on a main computer and accessed from the laptop with ease. This avoids constant file transfers and having to remember which computer holds the most up-to-date files.

Digital camera

Nothing fancy is necessary here: Any cheap digital camera is excellent for setting up reference shots. Examples could be how light falls in from a window, references for foreshortening, and perspective references.

▲ Digital sketchpad

A tablet PC might be exceptionally helpful to the artist who works in a completely digital medium.

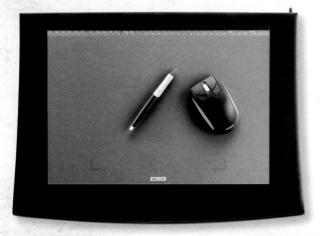

▶ Picture quality

For taking photos to use in your art, invest in a top-of-the-line camera, but for reference shots, a handy digital will be your best friend.

▲ Tablet

A graphic artist can "draw" directly on the display surface of this slate-shaped mobile computer using the digital pen shown. This tablet is 12 x 18 in. (31 x 46 cm), but smaller formats are available.

Keeping a Sketchbook

Learning to articulate your ideas on paper means that skillful draftsmanship is the first step toward fantastic finished creations.

Exploratory sketches

Rapidly drafted thumbnails and caricatures are handy for capturing a given mood or experimenting with a potential idea for future reference. They are not intended as anything more than blueprint notes for future work. Avoid getting bogged down in detail. Use these types of preliminary sketches simply to record an idea or a concept rather than perfect a finished drawing. Above all, create a visual vocabulary that works for you.

Scale

The dimensions of your sketch will have a major impact, both on the style of linework you select and the size to which the artwork can be expanded or reduced. Usually, the bigger the scale, the more successful the final version. Although it is not advisable to enlarge a tiny image, the linework and details can be scaled down effectively. There is a fine balance to be negotiated along the way, however, as a line drawing takes longer to produce the more its working size is increased, and a super-sized illustration can cause problems.

Linework

Avoid laying down strong, heavy lines that are difficult to modify or erase, and make sure you do not second-guess the inspiration process as you proceed. Keep your drawing style loose and confident. Give equal attention to posture, gesture, and expression. The benefits of an assured, confidently rendered sketch far outweigh the potential mistakes an illustrator can make along the way.

Laying down the line

Ideally, lay down single, loose lines with every application. For example, if you are working on the curve of a forearm, draw it in a single stroke. If it looks wrong, redraw the whole gesture until you get it right. Reworking an illustration can be daunting at first, but with practice, your sketches and linework will improve.

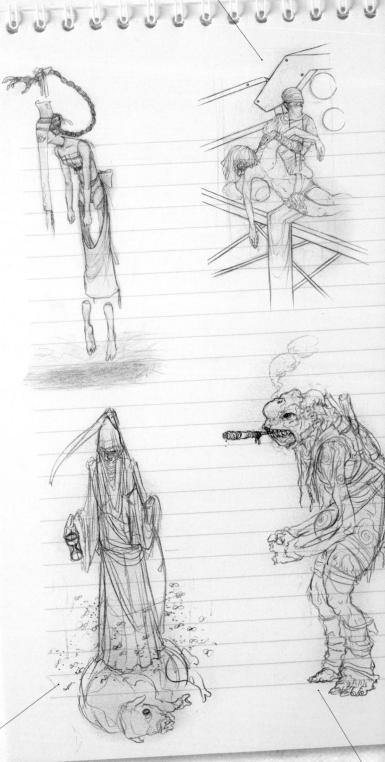

This delicate sketch (below) captures the drape of the loincloth and of the patient's turban, and the surgeon's magnetic gaze. Notice how the drawing conveys the weight of the listless body.

Incongruous elements in strange combinations create striking visual alliances. Witness the shrouded necromancer character (right) standing on what looks like a cow or a pig.

The most striking detail about this reptilian character (above) is the humorous touch added by the lit cigar.

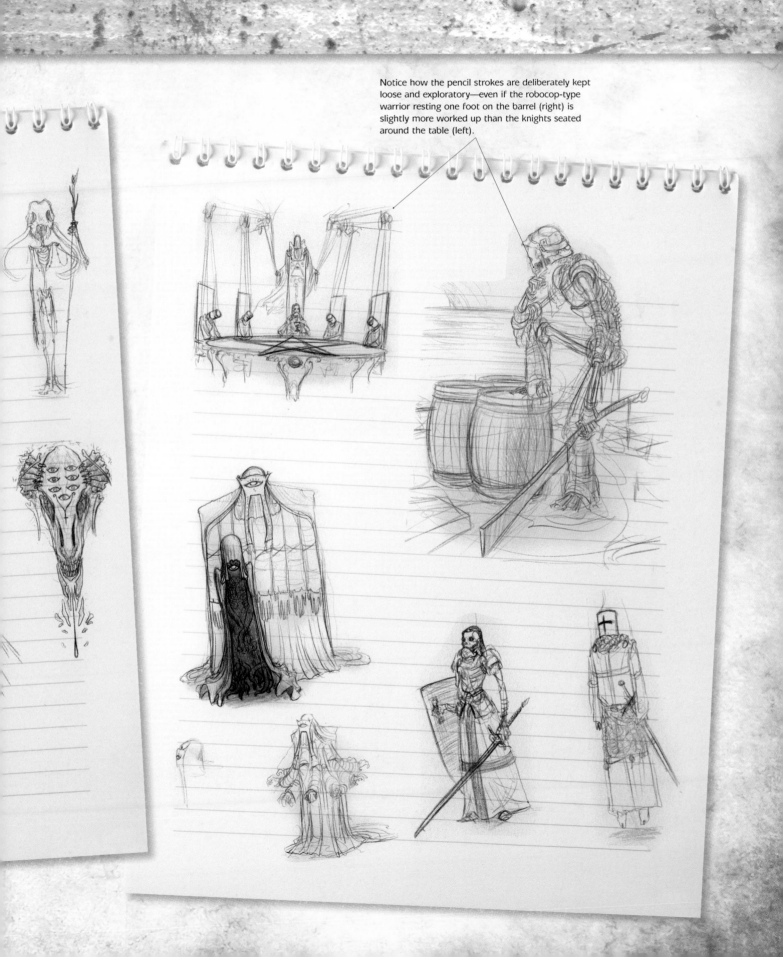

Notice how the pencil strokes are deliberately kept loose and exploratory—even if the robocop-type warrior resting one foot on the barrel (right) is slightly more worked up than the knights seated around the table (left).

The Building Blocks

The initial stage of character development in graphic art involves turning an inspirational idea into a full-blown illustration using different-sized thumbnails.

Thumbnailing

This simple start-up process involves producing a series of small, preliminary sketches to test the effectiveness of an idea that is still under development. Try to convey the character you imagined in your head on paper and start to produce a series of rough sketches. Don't be afraid to experiment—a messy sketchbook is better than an empty one, and of course, practice makes perfect! Avoid, however, simply copying existing concepts as this defeats the objective of any true artistic exercise.

Speed, size, and detail

The scale and level of detail featured in your work will be dictated by your own personal style and must be one you feel comfortable working with.

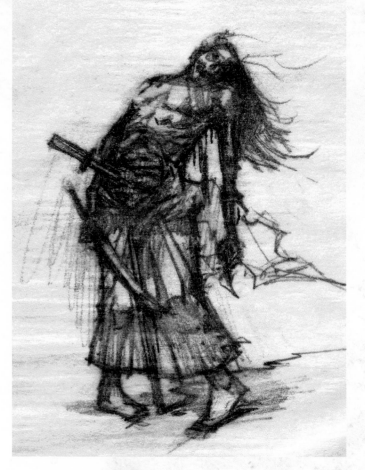

▲ **Medium-size thumbnails**
Unless another approach offers more tailored advantages, a fairly loose drawing produced at a useful size, such as 6 x 8 in. (15 x 20 cm), is the safest and most useful way of tackling any thumbnailing challenges. This approach should take up very little time, test the aesthetics and structure of the core concept, and, as an added bonus, be understandable to viewers. Focus on the most important parts of the design and concern yourself with details that make sense at the chosen scale. Aspects such as the gesture, clothing, and overall form of the character should provide the main impact at this stage.

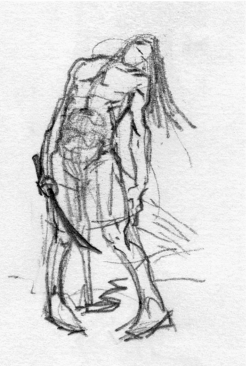

▲ **"Gestural" thumbnails**
These exploratory drawings (sometimes just silhouettes) serve a confident artist well, both in terms of the efficiency and speed required to capture a fleeting impression or idea down on paper. These small-scale sketches may appear unintelligible to anyone other than the artist, so you must test the aesthetic and conceptual viability of your design with care.

◄**Large-size thumbnails**
A large, detailed sketch will clarify major facets of your design, but it is labor lost if you do not incorporate any linework in the later stages. This method of thumbnailing can, however, slow down the progression of ideas as the time taken up by this initial draft might have been better spent exploring looser ideas more thoroughly. If you go down this route, you need to produce a fully realized sketch, a technique that requires confidence and a clear sense of direction. The degree of success varies widely, depending on the level of drawing and the artistic confidence involved.

◄This carefully rendered illustration is less of a thumbnail and more of a preliminary sketch. Notice the embedded samurai sword, peeling skin, thinning hair, disemboweled intestines, wasted face, and emaciated frame. With shade, form, and texture indicated, this sketch could be scanned in and used as the base layer for a painting in Photoshop.

Anatomy Exposed

If anatomy is the nuts and bolts of any standard fantasy or cartoon character, this is even more true of an animated undead creation. Let your army of vampires, skeletons, ghouls, and zombies challenge basic human anatomy as you learn to "dress" a naked skeleton, distort proportions, and "disease" the body.

Deconstructing the picture of health

An understanding of picture-perfect human anatomy will teach you the parameters within and beyond which your imagination can "distort" and "deconstruct" an undead cadaver. This sort of creative control allows for the most bizarre creations to become convincing artworks. The section will first focus on healthy human anatomy and then move on to dissecting, distorting, and diseasing it to make creepy designs.

Back to basics

Imagine all body tissue has been stripped away from a figure, leaving the skeleton bare (as shown right). Featuring different kinds of undead skeletal creatures in various stages of decay is an excellent opportunity for peeling back the layers and coming to grips with the way the body's core looks and moves. In undead designs, the skeleton is the least ghastly of all anatomical manipulations. With the right touch, an animated skeletal form can take on a melancholy elegance, losing any repulsiveness, so make sure that horror is always present as a component in your art.

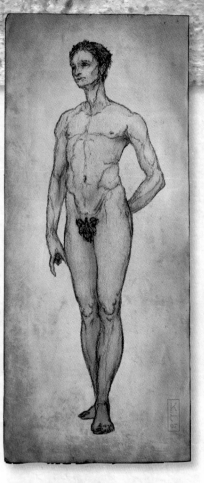

▲ **Realistic versus stylized art**
Unless you prefer working in a way that is completely faithful to reality or photorealistic, some degree of stylization will inevitably creep into your art. The proportions of your figure may change, but, as long as these shifts are kept consistent and work with the core concept aesthetically, fostering your own individual style is not a bad idea.

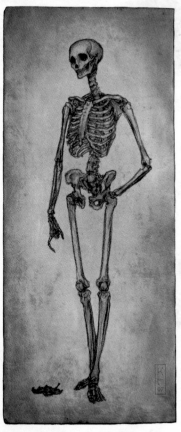

◀ **Skeletons that are "alive"**
Animated skeletons are frequent protagonists in gothic and horror stories, as well as biblical and mythical art. More modern examples could include a futuristic contraption or an ethereal presence like a necromancer manipulating armies of brainless skeletons.

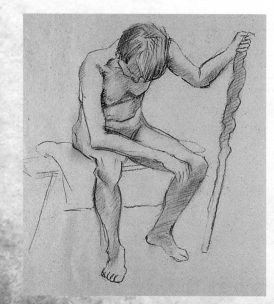

◀ **The human model**
Practice life drawing on a regular basis to develop a good understanding of the human body's proportions.

Being medically curious

From constructing a skeletal frame to knowing how to layer, as well as peel back organs, tissues, muscles, and skin, understanding the foundations of human anatomy requires precision, passion, and application.

Accurate anatomical description is at the core of striking and truly terrifying undead graphics. You can either "deconstruct" a healthy anatomy into a distorted, decaying, and dismembered figure, or simply add layers to a skeletal foundation. It all depends on how and what you wish to create. Knowing how to depict the weight of hanging body parts, or mutilated and amputated sections, is an extension of mastering anatomy. Look at these nineteenth-century etchings taken from medical manuals. They are biologically accurate yet still retain character and even a note of humor!

▲ ▶ **Anatomical illustrations**
Drawn by Andreas Vesalius of Brussels in the sixteenth century, these beautifully etched drawings were featured in *Gray's Anatomy* (1858), one of medicine's classic landmark texts and the pinnacle of anatomical decription for all nineteenth-century physicians. Use them to try to identify the body's main articulation points.

Peeling back the layers

Many undead characters have violent or tragic pasts with the signs of accident or misfortune visibly etched on their bodies and faces. The death blow is a classic example. With a thorough understanding of human anatomy now firmly tucked under your belt, try removing the layers that constitute your creature's anatomy and begin to show evidence of physical trauma. Curious enough, a violent impact seems to have little or no effect on the undead. Traditionally these creatures carry the most horrific wounds incurred at the time of their death! Other modifications brought for storytelling purposes could include, for example, removing limbs to make way for mechanical parts.

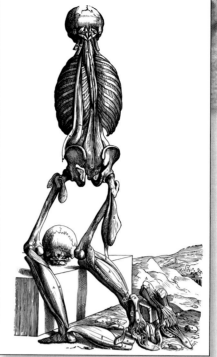

◀ Old engravings
The grittiness of antique surgical diagrams is these days sadly absent from modern science, which is very clinical. This illustration gives the viewer a good sense of how a human body without arms, and with partially removed skin, muscles, and organs, might look like in standing position.

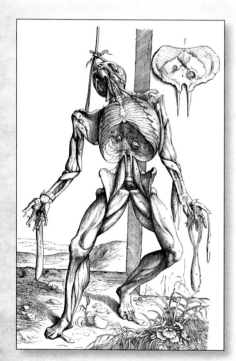

▲ Anatomical landscapes
Traditional anatomical illustrations are full of atmosphere and artistic flair, and serve the undead artist well. This example contains elements for an intriguing background story that could suit an undead character. Notice the linework, unusual pose, and striking composition.

Gender differences

The proportions between male and female figures vary slightly. When designing roughly human scale, use the nine-parts-to-one head-to-body ratio to determine the right proportions of your creature. In males, the neck will look shorter due to a bulkier, more pronounced trapezius muscle. The female pelvis will seem wider, making the angle of the femur or thigh bone look more acute.

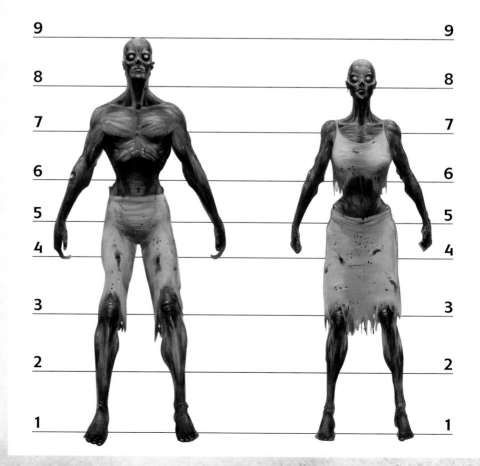

Putting it all together: anatomy, contrast, and lighting

While anatomical research and study are vital for formulating the initial sketches, these tools can prove less useful when you reach the painting stage. Make sure to keep one eye on your reference material as you drop color into your linework but be prepared to deviate from the original source material in favor of more dramatic effects.

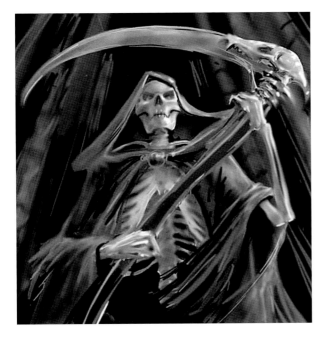

1 The original tonal sketch can be scanned in, placed as the base layer in a Photoshop document, and used as the basis for the painting. At this stage, the sketch of the figure need contain no more than basic lights and darks.

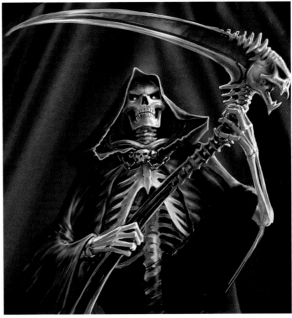

2 On a separate layer, the basic colors are laid over the tonal base sketch. This digital treatment helps the figure come together in more detail. The background tones are defined on yet another layer.

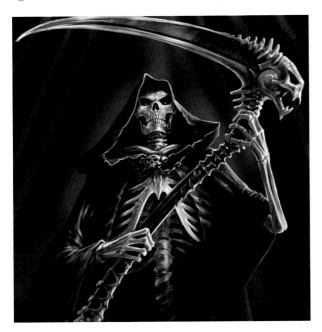

3 The basic background colors are added in and fine detail is used to further refine the main figure. Notice how multiple folds are worked into the cloak's fabric.

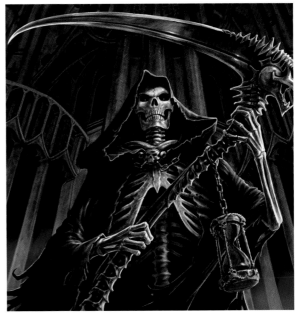

4 A full range of details are painted over the background tones and colors. Highlights and shading crystallize the figure and the dangling hourglass is added in at the end.

Distressing skin

Most undead characters often have horrific lesions, their faces a mangled patchwork of scars. Magical or supernatural influences can be conveyed through unearthly, beyond-the-grave tones, and the effects of pathology or deformity can take character design to exciting new levels. Whatever the source of your inspiration, the color of your creature needs to be thought about carefully. Remember, whatever you create must at all times retain its capacity to generate fear or worse!

The kiss of death

This visual direction is the most challenging to convey. The clues required differ from those that characterize physical trauma or decay (see pages 30—31). The presence of undeath can be conveyed through translucent skin tones, bloodshot eyes, and sallow, flaking skin.

Disease and deformity

The themes of contamination or disease work particularly well with undead character designs. Creatures affected by infection or deformity will sport lesions, scabs, broken veins, atrophied tissue, flaking skin, rashes, blisters, and other symptoms of being unwell and undead. Physiological symptoms of infection like pus, for example, are interesting because they have the capacity to indicate that an immune system is trying to resist disease or potentially fighting back a parasitic or viral invasion.

Mutations

Introducing mechanical ravages to a creature's anatomy or genetic cross-breeding (say, between animals and human elements, or between plant and animal elements) to your design involves a different approach altogether, and allows the artist to combine ideas unthinkable in the real world. Be they congenital or environmentally induced, mutations produce fantastic undead creations.

The color spectrum of death

These "deadened" hues will help give any reanimated corpse a wretched appearance, making it look diseased, infected, bruised, rotting, or simply bloodless—the choice is yours.

Sallow skin: Flesh Tint, Buff Titanium, Rose, Payne's Gray.

Rashes and flushes: Rose, Flesh Tint, Buff Titanium.

Superficial bruises: Deep Purple, Flesh Tint, Deep Violet.

Nasty bruises: Payne's Gray, Deep Purple, Deep Violet.

Half-dead flesh: Flesh Tint, Buff Titanium, White.

Anemic complexion: Buff Titanium, White, Sap Green.

Ashen tones: Middle Gray, Sap Green, Buff Titanium.

Necrotic tones: Middle Gray, Payne's Gray, Sap Green.

The ethereal

This category of undead has moved beyond the confines of the physical body. Ghosts, specters, apparations, and spirits exist on a different plane than mortals and manifest in ways different from the Half-Life or the Walking Dead. They are depicted in varying degrees of transparency, with parts dissolving into mist or smoke, or with body sections obscured in permanent shadow. Visual effects that mimic smoke, water, flames, and light are useful for developing these kinds of being.

Keeping it mysterious

Ethereal creatures move about unconventionally, hovering, floating, suddenly vanishing, or being carried by the wind. Although some examples are half-formed physically, they can easily travel between and within worlds.

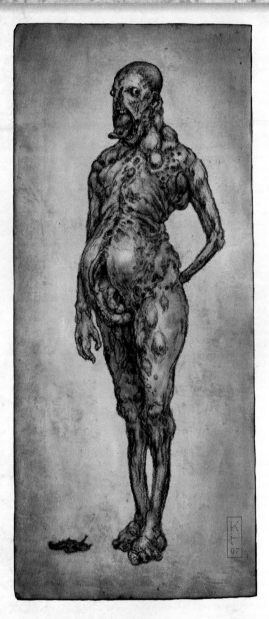

▲ **The ambiguity of disease**
Compare this infected and deformed creature which is a reworking of the picture of health shown on page 24. Deconstructing and retouching the layers on a healthy anatomy can produce disconcerting results even for the artist.

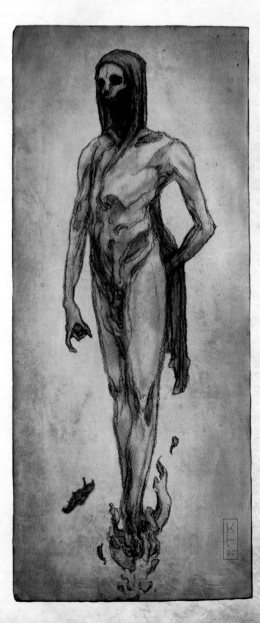

▶ **Bending physical laws**
In incorporeal designs, the artist can ignore the effects of gravity. Consider this study of a hooded, skeletal-type figure which looks as if it is slowly decomposing or combusting, judging by the upwardly floating ashen embers from the conflagration at its feet.

Layers of Decay

Undead characters straddle life and death—an uncertain state that has major implications for their physical appearance. As the notion of evil is often a major component, each of your designs should look unnerving. Here are a few tips and ideas for increasing the "creep factor" or level of repulsiveness.

A carnival of horrors

This section contains a series of half-dead walking cadavers in various stages of decomposition that also represent different levels of creepiness. They have the appearance of having once been human, but details woven into their presentation indicate a violent history, the passing of time, or simply the outward reflection of a corrupted core. Below are some of the telltale signs to confirm a creature's state of undeath. You might wish to incorporate some or all of these treatments in your artwork. Remember that many of the lessons learned when working in elements of decomposition can be applied to introducing mechanical damage.

Back from the threshold of death

Give your character an unhealthy or unearthly expression to indicate that it has returned from the other side or is straddling its doorway. Introduce rheumy eyes, an addled stare, bloodshot bruising, or a supernatural glow. Experiment with the texture and hue of skin, removing all warmth from it. Turn to page 28 for the colors of death. Undead characters might also have suffered recent injuries (often with entire body segments missing) but will not react to or feel pain. They defy the physical laws of nature so this lack of a pain threshold or sensitivity needs to be conveyed well. Turn to page 29 for more ideas.

Marking the passage of time

The natural world eats away at everything, be it dead or half-alive, buried or wandering. The stage at which rot and decomposition take hold has the greatest shock value in undead graphics. Progressive tissue decay and the ravages of time, however, do not have to compromise strong characterization. Take a creation like a brilliant but twisted alchemist character as an example. As his mortal shell rots away, he could retreat into the dark corners of his mind. Remember that a rotting body undergoes a series of transformations, such bloating, bruising, and tearing, as it starts to fall apart. Choose your effects carefully and employ them suitably, keeping in certain visual cues to support the essence of your character at all times. Undead beings who have "died" in arid, dry conditions, for example, might possibly look yellow and desiccated, whereas drowned sailors could be shown swollen and either pale or purple.

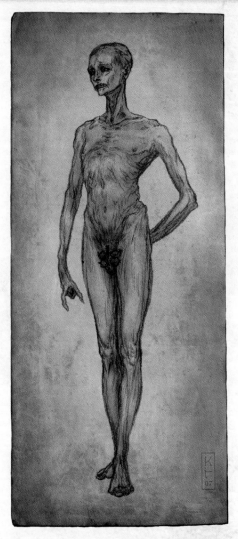

▲ **Almost human**
This illustration could easily be mistaken for an unhealthy human being at first glance were it not for a series of subtle details that confirm its state of undeath: the loose, hanging skin; the gaunt face; and the tight, thin-lipped mouth.

The creep factor

Every undead creation needs to have some unnerving or disturbing quality about it. If this aspect is missing, something has gone wrong somewhere in the creative process. Let's investigate the boundaries of what defines the creep factor in the twilight world of the undead. It can be as obvious as a physical deformity, as penetrating as a piercing stare, or as subtle as an unnatural set of features. The choices are limitless.

A creepy appearance versus creepy behavior

An undead figure can look disturbing—through incorporeal body parts, mechanical injury, decay, or physical deformity—or simply be a creepy presence. Although the first kind of sinister quality is more hard-hitting, it can be too obvious. Behavioral creepiness is more intangible and requires the viewer to process the information being presented. Having your audience infer that your creation walks with a pained, twisted gait will add dimension to your illustration. You can also increase your creature's creep-factor by twisting chosen sections or details. For instance, try stretching the features on a regular, symmetrical face so they take on a ghoulish appearance.

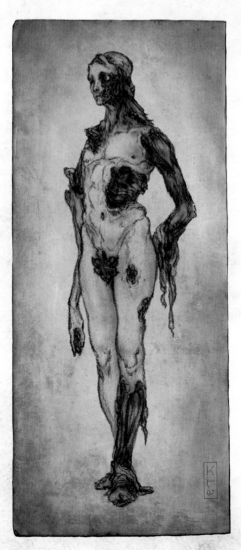

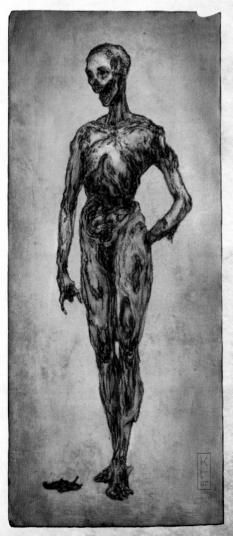

▶ **Advanced decay**
If the artist wants to convey a more advanced state of decomposition, body parts can be omitted or drawn as if they have fallen off (in this case, the jawbone). Consider how the pale, thin figure on the opposite page undergoes a striking transformation here (right) with a remarkable increase in physical creep factor. See page 29 for another variation on the same figure.

◀ **Initial rot**
If the artist wishes to introduce only the first stages of decay, the decomposing undead figure should retain most of its skin tissue and display deep sores in key places to show the muscle and bone underneath.

Character Poses

A character's ability to communicate movement and intent is a fundamental component of effective characterization. Corpses rely on effective poses to make their mark. Technical skill ensures that your crawling zombie is a terrifying, relentless threat rather than a figure showing symptoms of fatigue.

Presentation poses

Postures that we stereotypically associate with a "type"—an elegantly poised dancer, a saluting officer, or a praying monk—are known as presentation stances. These characteristic gestures are chosen when an audience comes to expect a particular type of treatment. In undead graphics, it is important to engage the viewer, but avoid complicity, as this could break the spell and dilute the impact of your illustration.

Static poses

On one hand, stationary poses are popular, easier to draw, and focus on conveying the mood or the psychology of a creature. They work well but can look dull. On the other hand, dynamic poses are better tools of narration, so long as the action is not overpoweringly distracting. You can achieve this by directing the eye of the viewer along your linework. Use tapering points, for example, to bring the eye around from the back to the front. Although the lethargic positions of some reanimated corpses might make them look as if they are in repose, there is always great potential in this specialist art field for terrifying action lurking underneath. A brain-dead zombie, for example, could be slumped over, devoid of any deliberate gesture and completely lacking in implied movement, but not look static.

Transitional poses

A character turning around, a soldier reloading or cleaning his weapon, a ghostly scholar holding up his quill—these are all good examples of transitional poses. Characters pausing in the middle of an action or about to engage in new movement fall into this category.

The importance of body language

If facial expression is restricted by a mask or the blank essence of a reanimated corpse, body language becomes critical for decoding the essence of a creature.

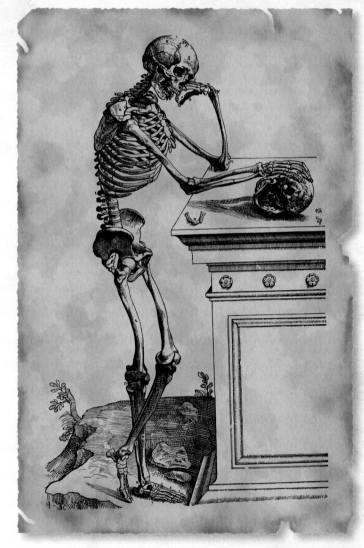

▲ **The thinking skeleton**
This kind of meditative scholarly posture—with the head resting on one hand—is typically associated with classical thinkers and philosophers. Transposed onto a bare skeletal frame, the same pose results in a uniquely bizarre piece.

▶ Twisting a natural pose

If the facial expression on your creature is disturbing or sinister enough, even the most common everyday stance can be transformed into a truly menacing pose. The most terrifying aspect about classic zombies, for example, is that they first appear as casual civilians before tearing you to pieces.

▶ Ethereal poses

Some undead beings are not earthbound but hover eerily or fly through the air. This figure is suspended, its limp limbs loosely dangling down, its right arm reaching forward. Consider its manner of movement. Regardless of the chosen rotation, keep the mechanics consistent.

Shuffling

This classic zombie pose sends up what appears to be a severe lack of body coordination.

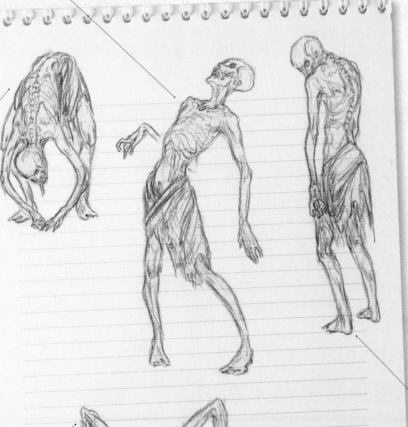

Hunched over

This hyperextension pushes the boundaries of human anatomy to their limit. The figure is shown hunched forward—almost down on all fours.

◀ Static characterizations

Zombies have the appearance of living creatures, but their lack of free will can make any movement look robotic and mechanical. It's up to you and your ingenuity to breathe personality into your creation. When well executed, even so-called "static" poses can reveal personality and intent.

Prostrate

Although lying face down on its stomach, this zombie figure is in the process of getting up. Undead characters in transitional poses have a greater potential for sudden action than those that are lying face up, and are therefore far more menacing.

Brooding

This looking-over-the-shoulder pose conveys a sense of evil machination. The stance is strangely intimate, almost self-conscious, as if the creature had been caught plotting as it stares back at the viewer.

Action poses

To work well, these kinds of poses must be visually "active" and shed light on a character's behavior, indicating how it interacts with other characters and its environment. Dynamic poses demand more elaborate backdrops and more elements of interaction. Choose a static pose if your primary focus is getting the look of your illustration right.

Matching character and pose

The action pose chosen must naturally suit the "walking dead" nature of your creature. Remember that these are all dead bodies reanimated by supernatural means, so any unexpected twists may even enhance your original concept. Where you can, vary the body proportions and pay attention to the distribution of weight. Avoid sheer absurdity, or going for the truly obscure or out of character, just for the sake of it. To the right are examples of risky creative decisions that paid off.

Challenges and solutions

The scenarios described below are intriguing because they set a design challenge and offer a creative direction for getting around the problem. Don't shy away from adding your own personal touch to these exercises.

Flying zombie

This creative brief strays away from typical descriptions of zombies as shambling, rotting corpses. The solution is to make the action integral to your design, so give your creation a jaunty name such as "Spring-Heeled Jack." Decay its flesh, thickening and accentuating tendons and ligaments for an added emphasis on movement.

Tall, lumbering vampire

Stealthy and sophisticated, vampires are universally linked with their nighttime thirst for blood. Invent an evolutionary regression for an imaginary bloodsucker. Imagine that after 500 years it grows to huge proportions, gains brutish characteristics, and loses its mental capabilities.

◄ **Lurching forward**
This hungry zombie displays visible signs of desiccation, decay, and emaciation on its face and body. The pose shows the creature clumsily reaching out with both arms as it shuffles forward, dragging behind one desensitized limb. Notice how the elongated leg adds to the slow but relentless movement.

◄ **Suspended levitation**
This faceless, sexless creature poses a unique presentation challenge: conveying a design that is driven by an intangible force but which is incapable of independent movement. The solution is to show it hovering in mid-air, its posture—shoulders back, arms out, limbs limp—strangely static to indicate its "possession" by an invisible, undeclared entity. Note the important difference between a motionless figure and a rigid one.

Exploring dynamic movement

Action is integral in constructing a character's repertoire, nature, and history. This is especially relevant for zombies whose blank, expressionless faces become animated only when they go on feeding rampages. Movement and posture therefore take center stage. Play out as many poses and attitudes as you can to explore the nature of this basic undead creature.

Wheeling around
This pose depicts the figure turning around to face the viewer. It is acceptable to throw a character off-balance so long as the direction of movement works well with the gesture shown.

Bludgeoning
This lazy and clumsy figure is preparing to strike a blow with a pair of bones held together like hand weights. The awkward tilted posture and ghoulish facial expression give away its undead status.

Howling
Overly aggressive poses are tricky, and must be carefully rendered, or they could interfere with your design, making it look incongruous. Take care when incorporating marked animal traits as they could feel at odds with the undead essence you are trying to illustrate.

Leaning
Though severely injured and leaning against a wall for support, this zombie figure is still capable of conveying a threatening posture.

Dragging
Using direct engagement with another figure, this pose depicts the zombie throwing its weight forward as it drags a victim between its legs.

Skewering
In keeping with its primitive nature, this zombie figure is poised to spear some target on the ground with what looks like a sharpened lance.

Fleshing It Out

Choose a strong concept and you're halfway toward nailing your final design. A well-explored core idea will produce memorable artwork and result in a superior illustration.

Multiple views

Start to resolve any initial conceptual issues through a series of rotations, and manipulate your character from different angles. A zombie's physical presence must be strong and the artwork needs to support this down to the smallest detail.

The most useful way of assessing a figure's sense of proportion in three-dimensional space is to draw your creation in a straightforward, standing position. Each successive rotation will then help to confirm the size and location of different elements within the design as they appear in relation to each other. Multiple rotations should probably never be used as initial concept ideas because the stiff poses involved might limit the possibilities of your design. These rotated views are purely informative and should not compromise the overall appeal you are striving for. A figure's visual expressiveness should be explored at gestural thumbnail stage.

Tall bearskin hat with plume

The wig's braided pigtail is visible only from this angle.

Fungal growths

Brass buttons

Hanging intestines

Loose-fitting trousers worn over knee breeches

The position of the zombie's shuffling, turned-in feet is most evident from this angle.

Frontal view
This is the angle that the viewer would most commonly expect to see. Although the sketching style is kept loose, notice how all of the key details have been incorporated.

Side view
Try to produce illustrations that are as informative from the side as from the front, giving you a good impression of the space occupied by three-dimensional form. Note how the fungal projections are more pronounced when seen through this rotation.

The importance of character props

Symbolic objects or accessories carried or worn by an undead character speak volumes about its origins. Anything that has a special connection with or adds layers of meaning to an undead design helps illustrate its nature, purpose, and intent. Well-chosen props contribute to the tale being well told, beg questions, and act as pivotal elements of contrast.

Customizing a weapon

The vast majority of undead creatures seem to have fearsome dispositions, and weapons are the accessories of choice. The gunner shield (below) is a good example of how a prop was customized for a zombie character belonging to an undead secret police force known as the Dead Rule Popular Corpses' Front. Referred to as "Pale Shirts," these thuggish enforcement officers use gunner shields to storm buildings targeted for inspection.

Creating a gunner shield

The gunner shield is a steel riot shield complete with a sighting slit and fixed swivel-mounting mechanism for firing a shortened repeater rifle. A full, three-dimensional realization of the device and its specifications is therefore key to the success of the overall design. The setting of the narrative is around the time of the Industrial Revolution, so this narrational consideration needs to fit both character and weapon.

Two-function design
This pair of realistic three-quarter views show the complexity of the gunner shield design (below). They give a vivid visual explanation of how the mechanism works in conjunction with the swivel-mounted firing rifle (right).

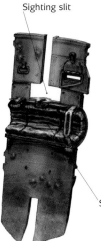

Repeater rifle

Sighting slit

Swivel mechanism

Front view **Rear view**

Epaulettes

With the zombie facing away, the viewer's attention is drawn to the torn sleeves of the jacket.

Brown satchel cartridge box

Rear view
This angle is always a handy point of reference if you are looking to produce a model sheet for a continuity-based medium, such as a comic strip or graphic computer game.

Modifications to the fungal zombie

In the first version of his design for a contaminated Napoleonic-era zombie, the artist came to the aesthetic conclusion that the fungus bursting from the zombie's uniform looked too cluttered and might create "readability" issues. He reworked the problem areas and presented an alternative treatment in the second version.

Making modifications

Particular elements in an undead design may occasionally turn out poorly. An efficient way to excise or replace an unwanted aspect is to print out the finished artwork, and work up any modifications on a separate piece of paper over a light table. When you are satisfied with your amendments, scan in these new sections and transplant them digitally. You are literally "patching up" the original artwork, so make sure that any repairs do not stand out.

Making additions

Sometimes a feature needs to be superimposed over an existing design. While not as potentially detrimental as removing an existing element, last-minute additions risk looking tagged on, and can also impair the composition's visual movement as they cut across already established lines of interest.

Making drastic changes

Where possible, major modifications to your artwork should be avoided in the later stages of the illustration process. However, if necessary, consider them carefully and ensure they are not so drastic as to throw the design out of balance. Mistakes can happen, making this a necessary step. An artist needs to know how to handle such mistakes and limit the damage to the effectiveness of the finalized piece.

Version 1

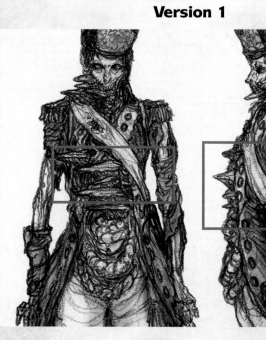

Version 2

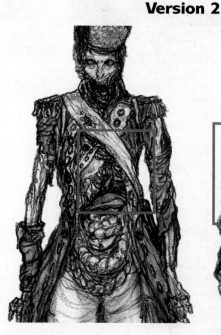

Front view
The artist obviously feels that these large patches of fungus compromise the visual accessibility of his design. From this angle, it's not clear how the parasite has wormed its way into its host underneath the ribcage and layers of cloth.

Side view
This profile view conveys more visual information by showing the fungus bursting through the military jacket in a series of spikes. They are distracting and the artist decides to edit them out.

Front view
This full-on view shows how removing the fungus exposes the zombie's viscera, leaving considerable gaps in sections of its torso. The artist proceeds to color in these sections using the same or similar hues as were used elsewhere on the body.

Side view
This modified profile view, with the patches of fungus removed, gives the design a clean symmetry. Note how more severe modifications would have affected the overall look of the figure's silhouette.

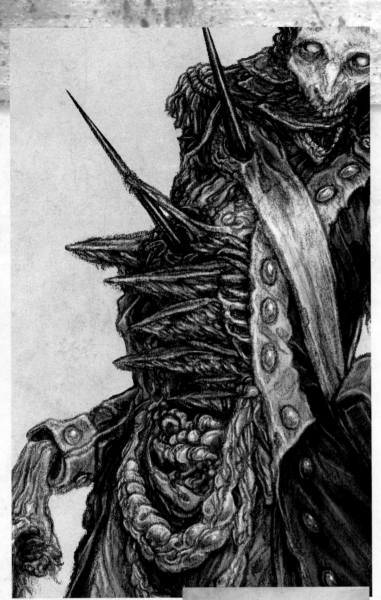

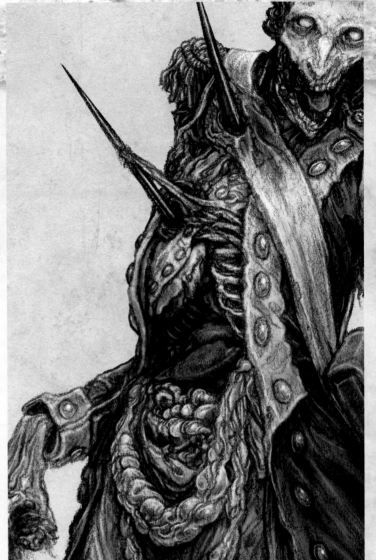

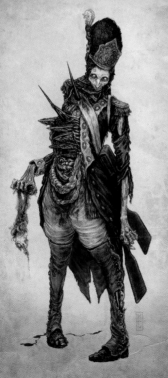

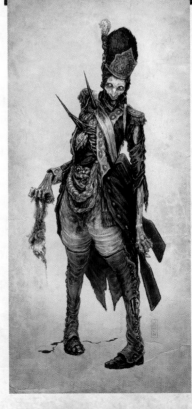

Version 1
Colorwork
Adding pigments to the first zombie presentation brings out the details that give this piece its impact. This close-up view shows the furry texture of the predatory fungus, the disemboweled midsection, and the bloodied scalp held up in the figure's left hand.

Details
Shown in its entirety, the final colorwork reveals more interesting aspects. Notice the red coattails of the military coat and how these direct the eye of the viewer to the trail of blood at the feet of the zombie.

Version 2
Colorwork
In the second presentation, the fungus has been removed, exposing the creature's liver and gall bladder. Sections of the jacket lapel have now substituted areas once occupied by the fungus.

Details
With less fungus now on show, the figure looks cleaner and more streamlined, the protruding bayonets somehow sharper. Oddly enough, however, the fungal encroachments in version 1 made the upper body of the zombie look more balanced.

Creating Atmosphere

When the atmosphere of a piece is truly convincing, all the elements are larger than life. The wind doesn't just blow—it screeches, howls, bangs like an angry fist—and there isn't just a full moon, but a bitter harvest moon, an eerie witches' moon, a baleful, gleaming moon. Well-chosen lighting effects help to manipulate mood and drama.

Lighting, contrasts, and balance

Dramatic techniques like low-key lighting and chiaroscuro (bold contrasts between light and dark in a scene) must be used evenly across a piece. Use stark light contrasts to create distinct areas of light and dark in your work and try to model objects three-dimensionally through highlights and shadows. In any balanced artwork, different elements merge and flow together effectively. The degree of "eeriness" is a measure of the visual and conceptual harmony that is ultimately achieved. For example, an undead character might have waded through pools of blood yet display body parts that are left unstained. Because most illustrations have defined areas of emphasis, compensations need to be made along the way to balance out content. Accentuate understated features alongside truly disturbing details. A cannibal butcher character could, for example, be wearing a beautiful decorative mask while holding a meat cleaver. The way lights falls on the subject will add that final key note of horror.

Making it real and atmospheric

Your initial aim should be to render your subject convincingly. Realism and readability will naturally compete with any stylistic choices made, so a happy balance must be maintained. Mood and atmosphere are secondary yet vital framing effects, and ambience can be painted or drawn over the original artwork. Alternatively, you can also overlay colored lighting or mist, or even manipulate fields of focus as a final polish in latter stages. Some artists may feel tempted to jump from the initial thumbnail sketch straight into the final painting, skipping the stages in between. Be aware that this shortcut will result in a very different visual end product, the most noticeable difference being diminished linework in favor of more dominant color elements.

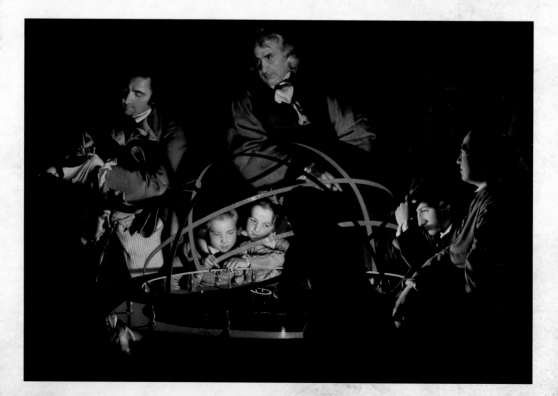

▶ **A masterpiece of chiaroscuro**

A Philosopher Lecturing on the Orrery (1766) by Joseph Wright of Derby is famous for its strong chiaroscuro realism under artificial light. Notice the dramatic transition between light and dark sections, from the well-lit faces in awe of the planetary model to the room's pitch-black darkness. Study other masters of chiaroscuro such as Caravaggio, Correggio, and, of course, Rembrandt.

Dramatic lighting effects

The way light falls on a subject can drastically alter the look as well as the mood of a piece.
Backlighting creates a mysterious, supernatural atmosphere, whereas uplighting gives a cold,
sinister feel. Here are some examples of different lighting styles and the effects they produce.

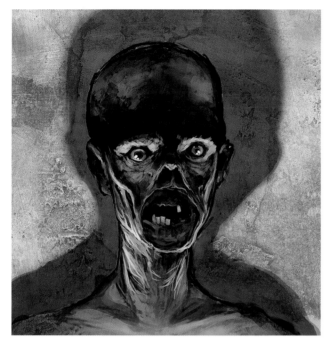

Dramatically sinister
Classic uplighting is a bona fide horror trick that runs the
risk of overexposure. Notice how it accentuates the
monster's eye sockets and casts huge wall shadows.

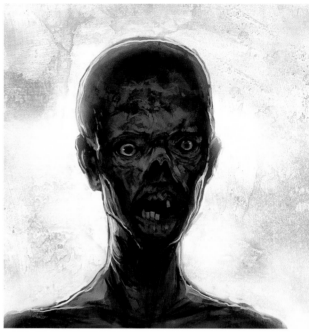

Surreal and otherwordly
Still pretty scary, but backlighting is more disconcerting.
Notice how it draws attention to the shape of the
monster's head and does not cast a back shadow.

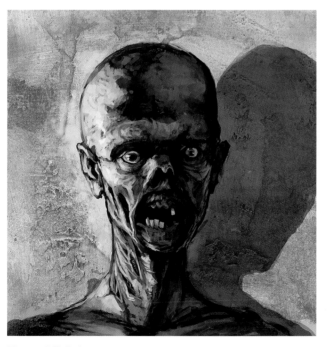

Neutral lighting
A standard style of lighting, and the one most commonly
used. The light source is coming from the right side, and
brings out the wasted tendons and ligaments on the neck.

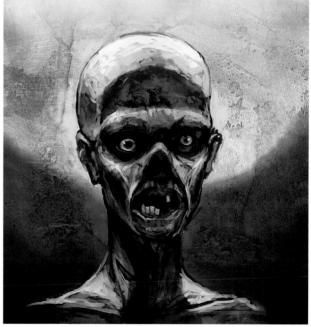

Deadly spooky
Always worth considering for a strong, dramatic effect, top
lighting imparts an interesting atmosphere. Notice how this
type of lighting illuminates the monster's skull and collarbones.



42

Creating a diseased monster

This gruesome creature was once Doctor Smedley, whose groundbreaking lab experiment on parasites went disastrously wrong. Having been attacked by an infected zombie, the scientist's twisted frame now swells the ranks of the undead. Observe how the thumbnail is the starting point and that the artist likes to work from back to front, or farthest to nearest.

1 The first step for creating any scene is exploring the initial concept through a series of gestural and exploratory thumbnail sketches. Try out different poses and compositions. Capture the key elements—in this case, the hunched pose and flailing stethoscope.

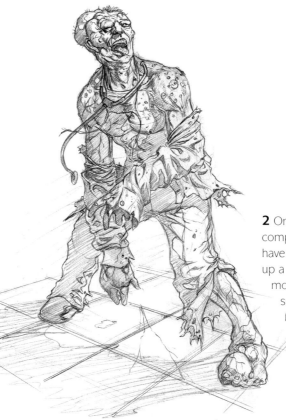

2 Once the basic compositional elements have been established, work up a fully realized sketch on mount board. With a smooth, drawing-paper finish, it will be strong enough to withstand the successive acrylic wet paint washes laid on top in later stages.

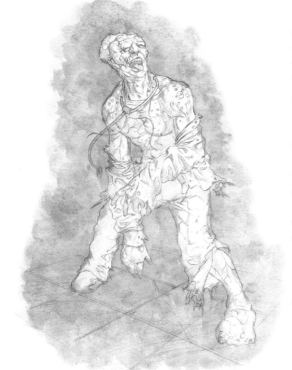

3 Choose the desired color scheme and identify the light source (top right as the cast shadows fall the other way). Working from back to front, drop in mossy green, the base color that will dominate the background, and then choose a midrange value for this area. Create darker values by adding gray to the base color, the shadows, and the tile grouting. Build up more value with several acrylic washes before lifting out the highlights using an opaque layer. If unsure, opt for a lighter finish. Keep the washes even in tone and texture.

Flesh Tint, Buff Titanium, White.

Flesh Tint, Buff Titanium, Rose, Payne's Gray.

Rose, Flesh Tint, Buff Titanium.

Deep Purple, Flesh Tint, Deep Violet.

Payne's Gray, Deep Purple, Deep Violet.

Buff Titanium, White, Sap Green.

Middle Gray, Sap Green, Buff Titanium.

Middle Gray, Payne's Gray, Sap Green.

4 Using varied washes and brushstrokes, start to introduce extra texture and subtle hints of different colors, particularly a dash of lime green for highlights to come. Add gradations of value, especially around the darker areas of the creature's trailing foot. Paint in the surface color and tile highlights using the more opaque layer. Lose the leading edge on the right of the vignette to unify where the detail fades into the color on the uneven edge around the figure. Repeat on the side with shadows to complete the background.

5 Work on the figure from far to near—the skin, for example, is farthest as the clothes sit on top of it. Drop in shadows and midtones using a combination of purple and green. Allow for some variation. Paint in an area of black, the darkest part of the picture, against which to gauge the other values.

6 Emphasize the figure's form, constantly mindful of the light source. The scientist is recently deceased so a pinkish hue is chosen for the middle skin tone (see detail). Deadly parasites have ravaged the monster's swollen, sore, and bruised complexion. The sickly green tinge of the atmosphere contrasts well with the gaping red sores.

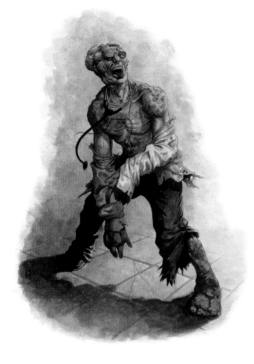

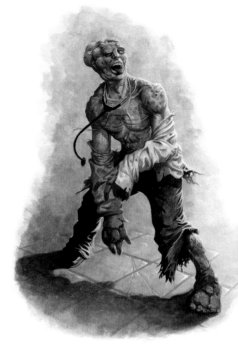

7 Continue coloring in the other items of clothing. The mossy green color scheme is still dominant, especially in the shadows and folds. Darker tones are added to the shadows as midtones. The trailing foot is blurred into the creature's shadow. These lost edges add to the heavy mood created by the strong shadow and lighting.

8 After the darkest values have been addressed, white is dropped in as the lightest value, followed by a sickly yellow/green hue to start lifting out the highlights. The light source from the left shoulder of the figure follows its outline. This rim lighting helps give the illusion of three dimensionality and adds to the atmosphere.

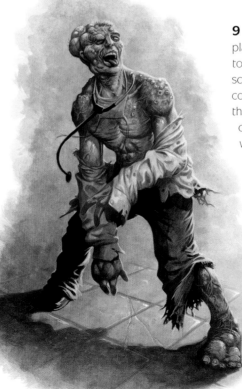

9 With key highlights now in place, extra highlights are applied to the creature's flesh. The scene's full value range is now complete and helps balance out the composition. More variety of colors are added to the skin, as was done for the background. The process is extended to the monster's clothing. Further color differentiation lifts the diseased areas to gruesome effect. Orange is introduced to the swollen tumors and the dilated veins are emphasized with applications of indigo.

10 The finished image is assessed as a whole. Shadows or highlighted areas are strengthened as needed. The final painting needs to hang together well and attention to detail is important in different areas of the painting. The last element to be added in is the drops of blood on the floor.

Evocative Settings

Successful backgrounds or settings lend the narrative strong visual support by helping to contextualize the central design in a way that adds dimension, interest, drama, and appeal.

Storytelling aesthetics

Whether you are presenting a single character or a busy, crowded scene, creating surroundings that are absorbing for the viewer is an important element of good graphic design. A strong background should be suggestive without stifling the focus of the piece. Identify hues that complement—not clash—with those already dominant in your design. Atmosphere is the cumulative result of the elements in your artwork and should not be overworked. Mood refers to the emotional tone that is evoked. It can be shocking, oppressive, striking, or subtle—it's up to you. Sometimes an uncertain mood works well because it unsettles the viewer.

Contrasting settings

While not always the ideal solution, a contrasting backdrop can enrich the narrative of your piece. Consider a dusty, shuffling mummy waking up in a futuristic laboratory, raised from its slumber by a group of clinical scientists. This approach to setting creates interesting visual and narrative tensions. Mood and atmosphere can also sometimes be at odds with one another yet still work. Consider a platoon of undead soldier ghosts. The general mood among the group could be one of lively

camaraderie, but the overall atmosphere is one of death and decay. Visual contrast adds richness and originality to your art, as well as poses new questions. An interesting example would be a shivering ghost depicted in warm daylight, or a dull, brutish, rough undead creature in luxurious surroundings.

Matching characters and settings

Think of a "matched" setting as one that enhances the narrative, look, and purpose of your undead creation. Nothing should ever look forced. Backdrops often function as decoration but can be important in establishing mood and conveying atmosphere. Getting them right is therefore important. Be aware of the pitfalls: oversaturation, overblown dynamism, and downright dreariness detract from the force of visual impact and can make a piece look absurd. Check every potential element against your figure so there is a perfect match between character and setting. Consider contrast, tone, symbolism, and color. Above all, avoid simply superimposing disparate components on top of one another.

Immediate and implied storylines

The first kind of plot hits the viewer right away and focuses on the action unfolding in the artwork. An obvious storyline may be the most engaging type of storytelling but, in the interests of depth, good graphic art should extend what is written to present an implied story as well. Although a creature design will usually present a specific timeframe, the implied storyline is what the viewer is allowed to deduce. In other words, the events that have either preceded the scene or will follow it.

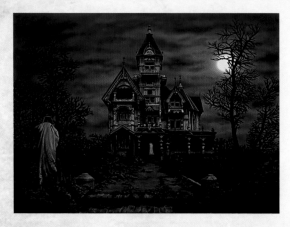

▲ **Haunted setting**

The artist used photographic reference material as his starting point. Tweaking all the elements in the process of painting the scene, however, helped heighten the overall creepiness. The house grew taller and more dilapidated, the undergrowth became more overpowering, the statue on the front lawn turned into the ghost in the doorway, and sinister blues and blacks were chosen as the color scheme to characterize the vignette.

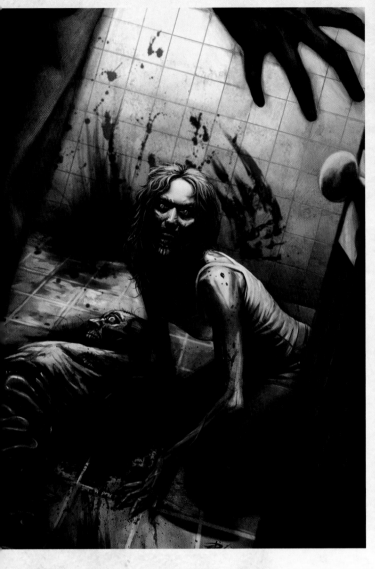

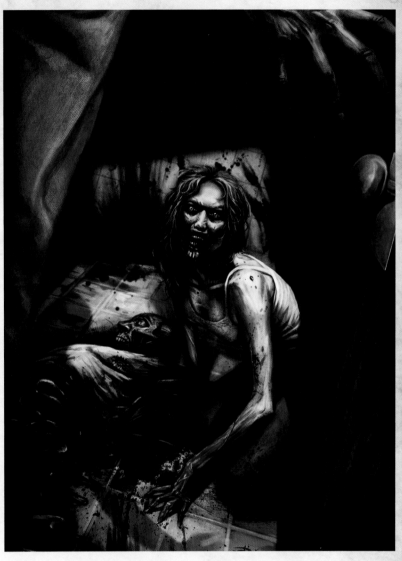

▲ **Dirty and creepy**
The lime green color filter casts a dirty pall over this toplit setting, imparting a feeling of rampage and decay. The direction of light throws all emphasis on the central female figure, fading the observer in the extreme foreground. Interestingly the intruder comes across more as an accomplice than as a victim.

▲ **Dangerously intimate**
A blue-gray filter gives the same scene a hungrier, more brutal feel. Framing the desperate cannibal girl is the high-contrast shaft of light coming through the open door. The secondary light source cast on the hapless bystander reminds the viewer of the element of danger to this new, potential victim.

The Finer Details

Making strong, decorative interest a feature of your work helps give a finalized piece presence and steers the viewer directly into the scene being presented.

The power of embellishment and symbolism

In Western culture, death is usually given the name "the Grim Reaper" and depicted as a skeletal figure carrying a large scythe and wearing a black robe or cloak with a hood. The artwork shown here is called *Pestilential Advent* and is an elegant reworking of the personification of Death through key symbolic embellishments. No matter how minimalist the finished style, or bleak your undead subject, disparate elements will have to be reorganized in an aesthetically pleasing way. Remember that any general aesthetics can be reworked if some of the decoration was initially inappropriate for the chosen material.

Reworking the figure of the grim reaper

Characterized by a strict composition, heavily symmetrical elements, and dominant lines of movement, the piece shows a stricken skeleton knight returning home from a devastating military campaign as the harbinger of pestilence. The overarching theme is one of horror at the spread of disease in a destroyed and apocalyptic world.

The sickly brown and yellow tinge of the chosen color scheme matches the mood and message of the scene.

The stone arch and pillars frame the skeleton and charger like a triptych or a piece of religious art, in keeping with the Christian roots of the personification.

The use and weight of different materials and textures—the silk yellow pennant, the velvet horse mantle, the braided mane and tail, the gleam of the burnished Byzantine halo, the tarnished armor, and the gleaming skeleton bones—help pull the piece together and convey the idea of the rich spoils of war even in defeat and despair.

The curved horizon line offers symmetrical and compositional support to convey the idea that this is a world at the end of its days.

Certain elements lack realism. The horse, for example, seems to float across the ground, a deliberate creative decision that contributes to evoking a dream-like atmosphere.

The insertion of subtle peripheral characters (like the cloth bearer on the right-hand side of the scene) have the potential for creating uneasy lines of movement that distract the eye away from the main artwork, and must be handled carefully.

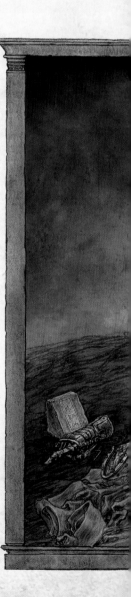

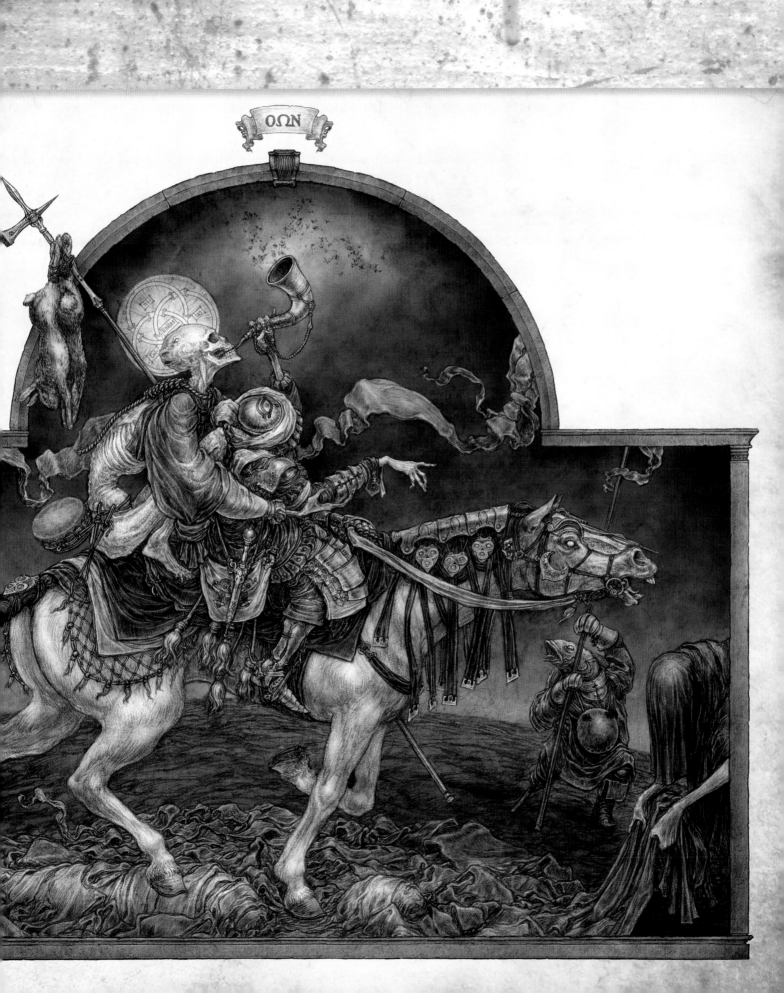

Artist At Work

The following pages discuss the different conceptual, compositional, chromatic, and graphic choices that contribute to a successful concept design.

Understanding how you work

One of the most useful exercises for any artist is to examine the components of the process by which final artwork is achieved. To understand your vision, and the different stages involved, work from the end back to the beginning. Try to identify several methods for achieving the same objective, then apply them the next time around. Finding idiosyncratic ways of achieving specific results plays a major part in any artist's progression.

Looking for inspiration

You will find yourself naturally drawn to material that then hatches an idea or a concept in your head. The main historical thrust for the painting—shown as a step-by-step sequence, starting on the opposite page—was the beaked plague doctors of the Black Death, but notice how a combination of eclectic sources shape the design of the piece collectively. Other visible influences are black-and-white photography from the World Wars, nineteenth-century European architecture, and early twentieth-century weaponry. Bear in mind that most influences are reinterpreted during the creative process.

▲ Protective gear
These curious outfits (left and right) were worn by doctors during the Great Plague of 1665. It was believed they protected the wearer against "miasmas" of poisonous air.

▼ ▶ The art of war
A French officer sporting an anti-gas mask,1916 (right); a kneeling soldier aiming the "new" Bazooka Joe, 1943 (middle); a German air patrol flying in formation over Poland, 1939 (bottom).

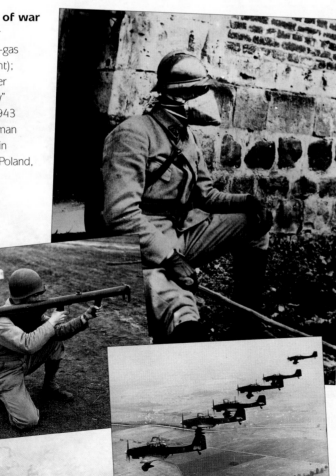

▲ Family of knives
This type of weapon comes in all shapes and sizes, from fearsome machetes to tamer fishing, hunting, or camping knives, down to pocket-size switchblades.

Working up an elaborate battle scene

While the rest of the book focuses mainly on single characters, this sequence shows you how to depict multiple figures interacting with one another in a set environment. This illustration effectively represents the culmination of all the art techniques learned so far. The detailed step-by-step progression, from rough concept art to fully realized piece, covers every major artistic stage, explaining the creative and technical decisions involved along the way.

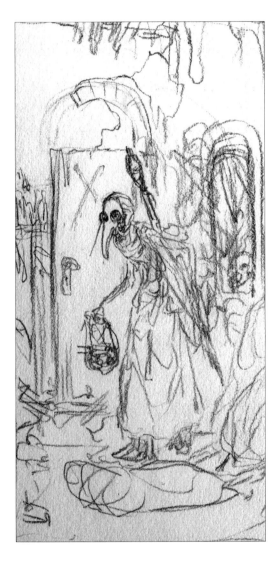

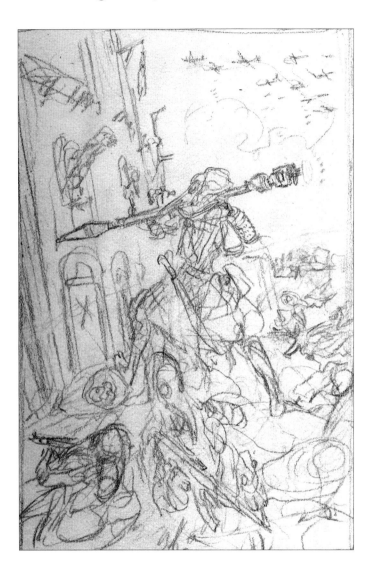

1 Working out the composition
The artist makes a few, quick test-runs to try out different ideas. His first exploratory rough draws the viewer's attention to a single, beak-masked character carrying a lantern with a bazooka strapped to his back. Focusing on a single character is a popular, engaging, and effective compositional device. A dilapidated doorway and window are loosely sketched in as background, but the overall impression is strangely static.

2 Second sketch
A second thumbnail explores a more intense, dynamically complex, and action-packed version. The battleground now contains several soldier figures in the fray. The main protagonist is standing on a pile of fallen bodies, aiming a raised flame thrower at the façade of the building. He shares the foreground with another comrade, who faces out. Notice how this rough-and-ready conceptualization has resulted in two possible yet distinctly varied compositions. Although the content might be conceptually similar, there is a distinct contrast in the two treatments.

The main soldier figure now faces out, engaging more directly with the viewer.

Details only intimated at in the thumbnail stages are defined at this stage.

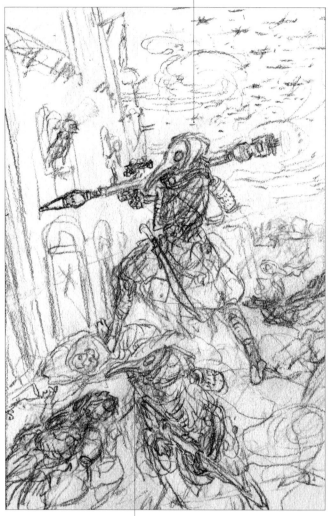

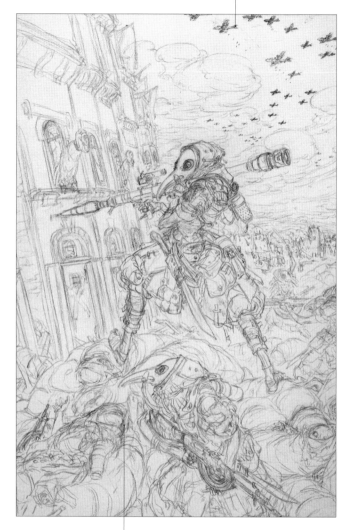

Compare the position of this figure's head with the face-on view shown in step 2 (see previous page).

Simple shading starts to suggest form and volume.

3 Modified thumbnail

The earlier stage (see previous page) identified potential problem areas in the piece. Two major but subtle shifts in focus are needed. The primary protagonist, the standing soldier, was somehow competing with the secondary figure staring out from the lower foreground. The modified thumbnail reverses the position of their heads, so that the full-length character now turns toward the viewer while the crouching counterpart is in profile, and is no longer a distracting element. This change will have a major impact on the finished artwork.

4 Final sketch

The sketch follows the layout and proportions of the detailed thumbnail with close precision. Although the artist follows through on most of the decisions made in the earlier stages, he still opts for shifting, developing, or toning down certain elements. Once this stage is complete, there is no turning back. The artist is now committed to this visual direction until the end.

Background: tone is less intense here.

Foreground

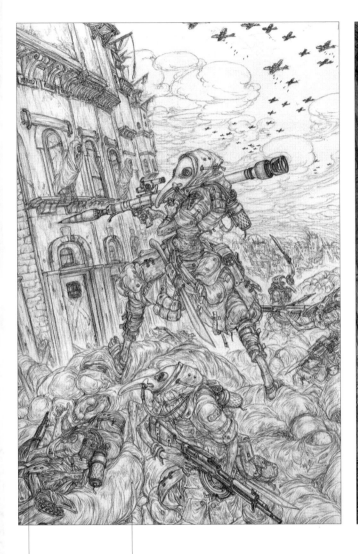

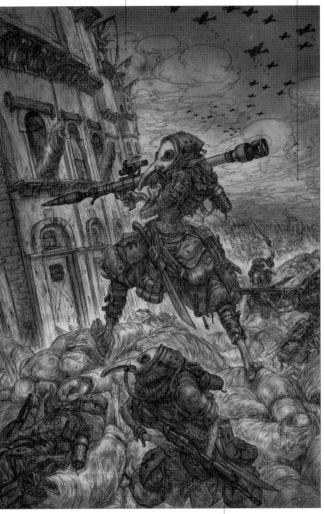

Some lines are applied with pressure...

...others are laid down with the lightest of touches.

Foreground plane

5 Linework and line variation

The quality of line should be good enough to represent a finished piece in its own right. Notice how the lines vary in thickness and gesture. In the sketching phase, these strokes were simply defining shape and suggesting volume, but have here been consistently applied with aesthetic qualities in mind. Movement and curve, for example, are expressed through different weights and types of line. Some lines take on a purely decorative function.

6 The effects of shading

Introducing contrast helps to establish a full tonal range that lifts the finer details and separates the characters from their background. The use of strong contrast is as much about readability as it is about adding realism. Simplify the process by splitting the scene into three distance planes. Treat them as flat pieces of art, with the distant background on top, followed by the middle distance, then the foreground laid over the other two. These distance planes should progressively get lighter, losing a degree of contrast as they recede into the distance. Make sure they merge without any sharp breaks in between.

Layers of blue dropped over the uniform dark red background create a foreboding sky.

A light red glow applied to the underside of the clouds reflects the inferno raging below.

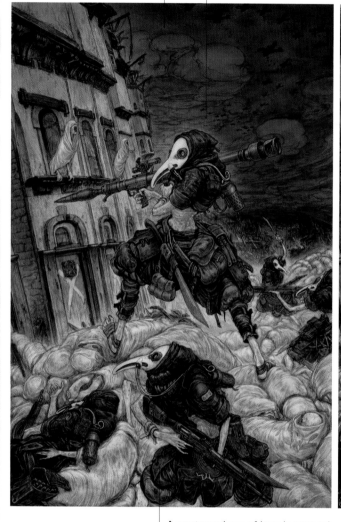

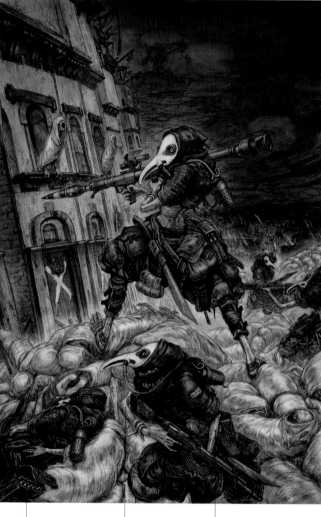

A greater variance of hues is reserved for the characters appearing in the foreground, with the ones further back being separated from the foreground by successive coats of a brownish yellow color.

Use cool blue for shadow areas.

Use a medium skin tone for the creatures' bared flesh.

Use warm yellow or pink for highlights on skin tones.

7 Glazes and overlays

Paints are opaque, whereas glazes are translucent. Even so, glazing will cover up any painstaking linework and shading in your work. Overlay several of these bare, translucent layers to produce three-dimensional effects such as depth, volume, and form. The effect will look dull at this point. What is important is to coordinate the overlays so they can be worked over in the steps that follow.

8 Compound colors and finishing touches

No part of the artwork should be solid sections saturated in a single color. Start with a base as a unifying hue, then compound it with glaze overlays on top. Think of each area as divided into a shaded color and a highlighted color, with a main color in between. Map out most of each character's flesh area using a medium skin tone. Follow this application with a layer of cool blue over the shadow areas, and a warm yellow or pink over the highlighted sections. This vibrant interplay of colors will make the soldiers' flesh come alive. In the last stages, the final artwork goes through a succession of tweaks and changes. Certain parts of the scene are emphasized and others toned down to ensure the delicately balanced hierarchy of elements is maintained.

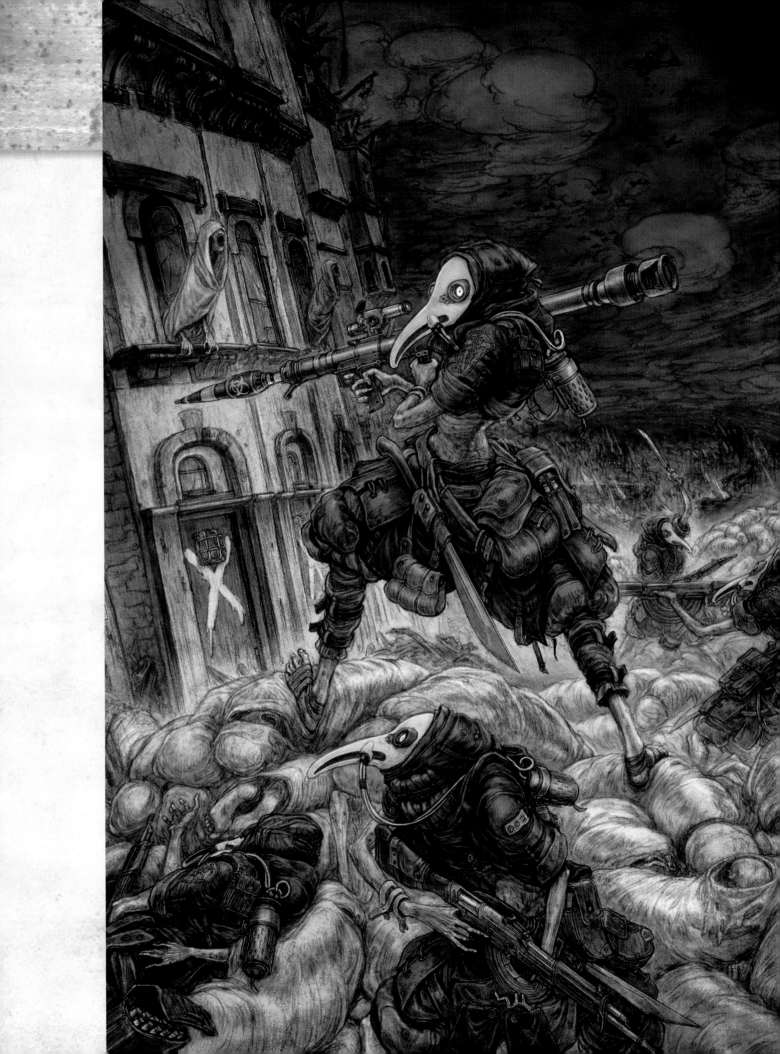

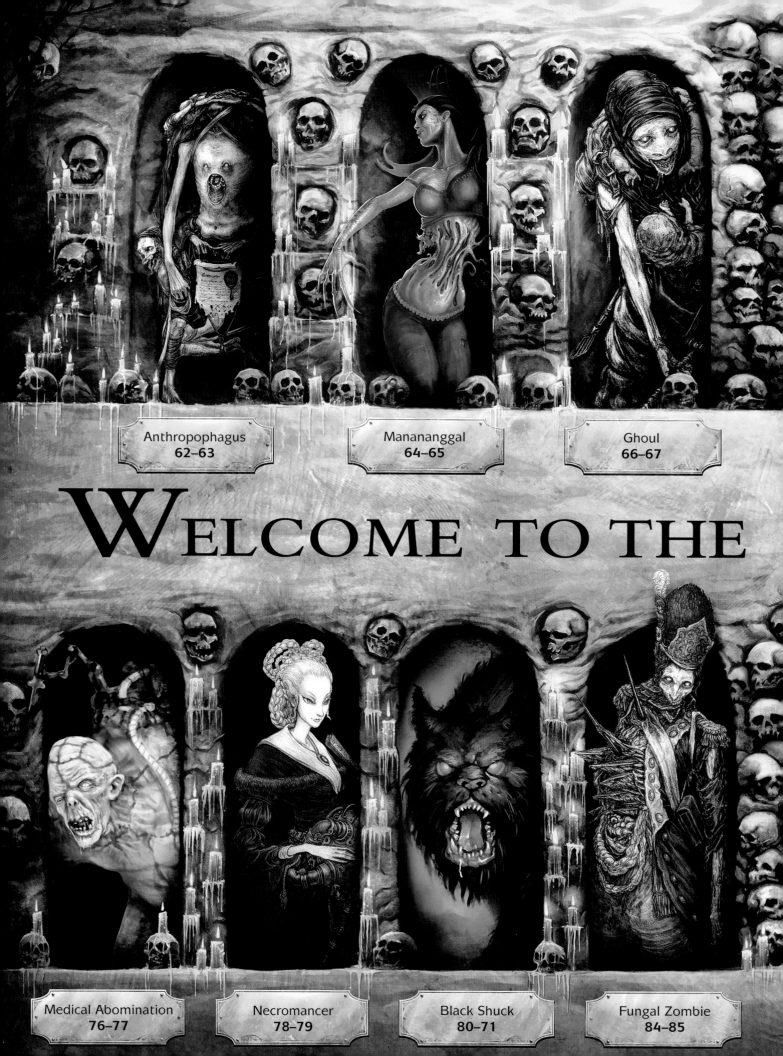

Anthropophagus
62–63

Manananggal
64–65

Ghoul
66–67

WELCOME TO THE

Medical Abomination
76–77

Necromancer
78–79

Black Shuck
80–71

Fungal Zombie
84–85

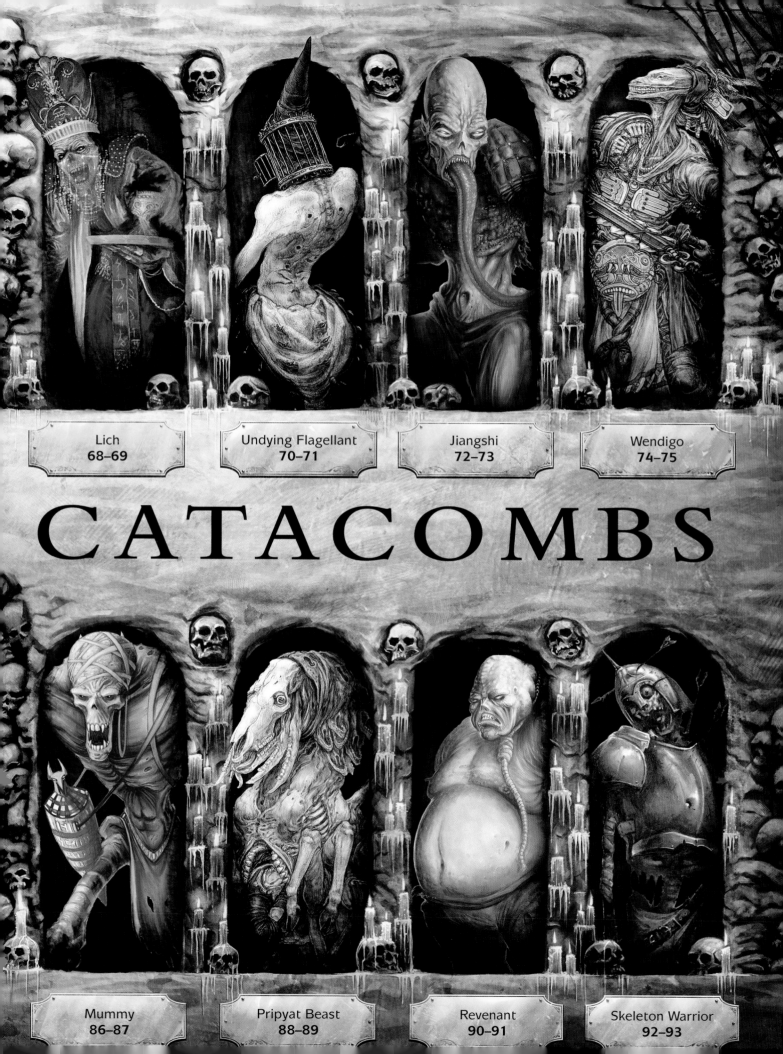

Lich
68–69

Undying Flagellant
70–71

Jiangshi
72–73

Wendigo
74–75

CATACOMBS

Mummy
86–87

Pripyat Beast
88–89

Revenant
90–91

Skeleton Warrior
92–93

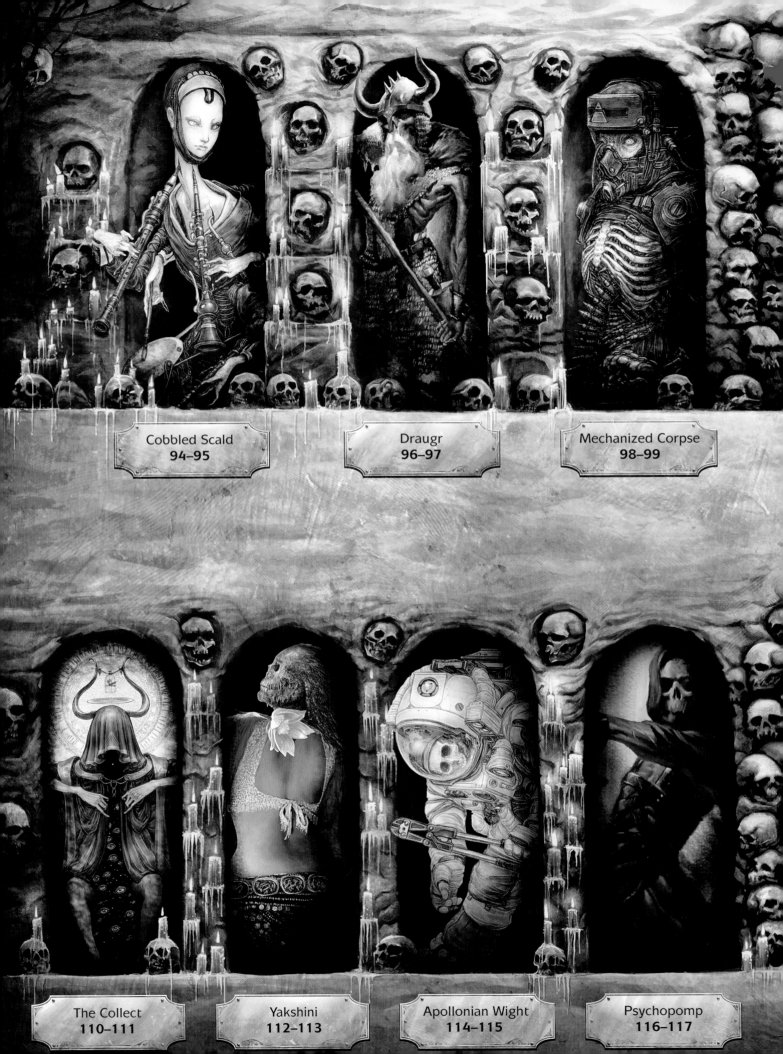

Cobbled Scald
94–95

Draugr
96–97

Mechanized Corpse
98–99

The Collect
110–111

Yakshini
112–113

Apollonian Wight
114–115

Psychopomp
116–117

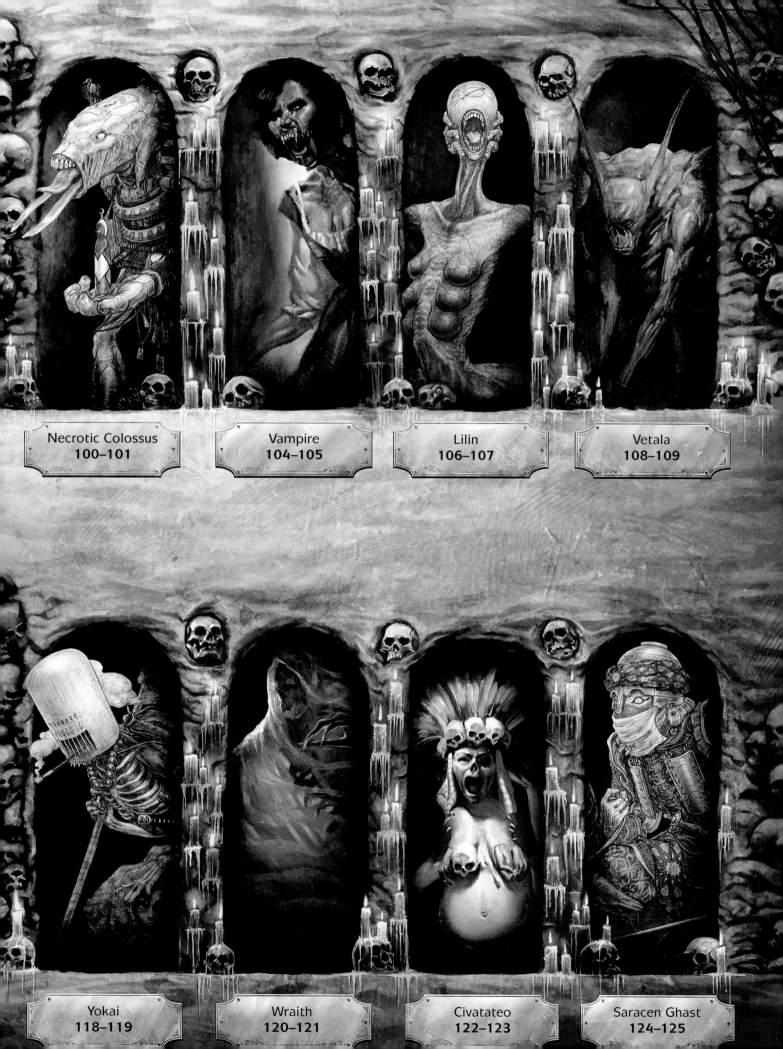

Necrotic Colossus
100–101

Vampire
104–105

Lilin
106–107

Vetala
108–109

Yokai
118–119

Wraith
120–121

Civatateo
122–123

Saracen Ghast
124–125

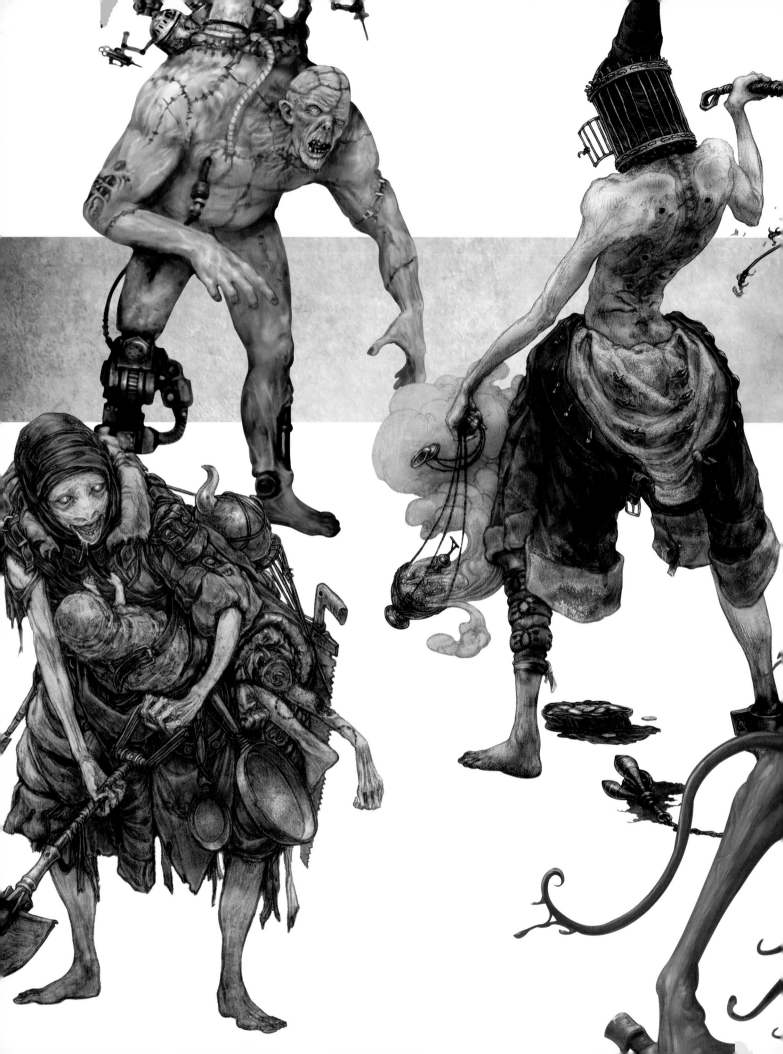

The Half-Life

This variant of undead includes all kinds of monsters—winged vampires who tear at their bodies at feeding time, masochistic monks who mortify their bodies with the pleasure of pain, and necromancers with dark yearnings for procreation. Some of these creatures are spellbound by bloody sacrifice and death, while others were brought into the world only to be spurned.

Anthropophagus

Although not undead as such, the cannibalistic Anthropophagi flock to the aftermath of battlefields where blood was spilled and body parts scattered. These extremely tall and headless human corpse herders march on relentlessly, reanimating the remains of the dead and consuming the flesh of the dying. Their enigmatic faces set deep within the cavity of their chests, they mumble to each other in a strange language as they collect human spoils and take to the hills.

Recreate this....

1 Transfer the thumbnail to a full-size sketch, finish off by adding details in pencil, and scan the image.
2 Import into Photoshop and shade with the "burn" tool set to "highlights."
3 Highlight with the "dodge" tool set to "midtones."
4 Add colors to a "soft light" layer.
5 Use the appropriate Photoshop tools to push back the hues of the secondary characters so they don't overwhelm the main character.
6 Place a paper or canvas background behind the character artwork.

In this sketch, the Anthropophagus corpse herder keeps three ghouls on a leash as they help it sniff out human remains on the battlefield.

▼ Thumbnail sketch
This basic standing pose works well for a main protagonist who is surrounded by other figures. Peering around the Anthropophagus are ghouls crouching on the ground. Supporting both background narrative and the visual appeal of the piece, this arrangement creates a broad visual platform for the final art.

▲ Historical basis
Ancient folk tales by travelers often spoke of lands populated by Anthropophagi. Fascinating drawings and etchings from different historical periods abound from which the recognizable myth springs.

▲ Sketch
Working in a hierarchy of detail can be an efficient and focused drawing method. You'll notice that the major elements of a design are sometimes so clear that other parts of the sketch lose definition and become looser. Always ensure that the sketchier parts of the design end up as basic, less detailed elements—nothing that might suddenly steal too much attention or abruptly unbalance your work later on.

▶Props: man-catcher

The wizard-like staff held by the Anthropophagus is a device for trapping and torturing unruly reanimated corpses. The spring-loaded catch of the heart-shaped mechanism snaps open and shuts over the neck of a victim holding it fast.

▼Finished art

The creature's skin color is offset by the pallor of the ghouls and the macabre costume details and materials. A signed license, complete with wax seal, worn at the waist confirms the Anthropophagus's qualifications in corpse field-picking. Notice how much of the clothing worn is made from human skin.

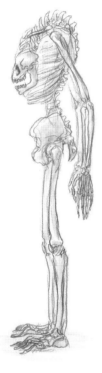

▲Anatomical detail

The skeletal structure of the creature shows that, despite an alien appearance, the underlying structure is basically human (see page 13). The major anatomical distortion is the rearrangement of the spinal column, which has been tucked into the ribcage. The front of the skull faces forward and the back of the cranium has been removed.

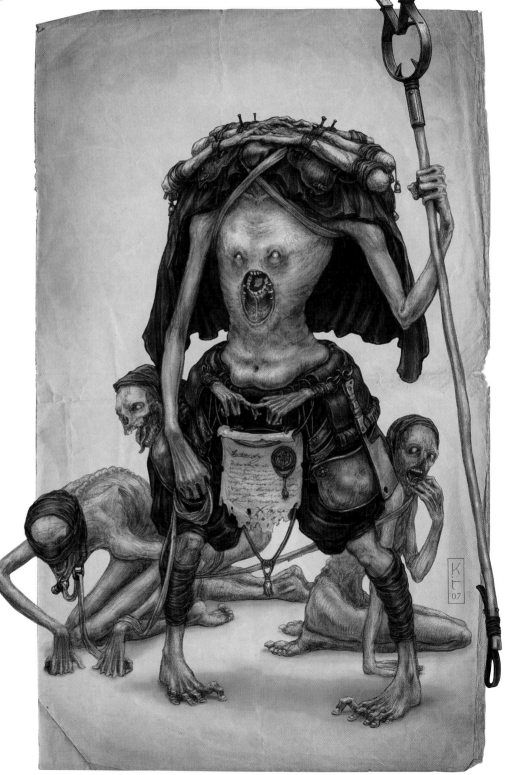

Manananggal

The Manananggal from Philippine folklore are winged female vampires who tear at the waist before feeding time every night. They fly over rooftops and run long tongues through windows to suck the blood of unsuspecting victims. There are hushed tales of drunken husbands returning home to find their wife or daughter severed at the waist, the head and trunk missing. After such a grisly discovery, they are further sobered to find their loved ones the picture of health the next morning...

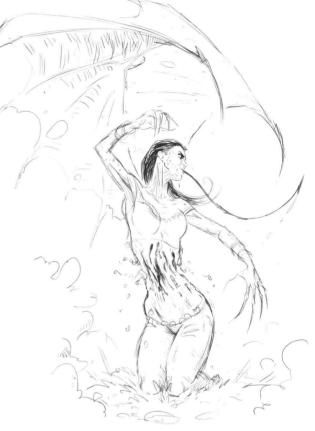

▼ Side and rear views
Wings extending from each shoulderblade are central to this design. Decide on their method of attachment by manipulating the original thumbnail sketch through two different rotations (profile and rear view). The solution hinges on a torso capable of flying away evenly once it has separated from the body's bottom half. Notice how the low-cut top allows the wings to join together at the back.

▲ Sketch
The Manananggal's midriff tearing away from her lower half becomes the central action of the final artwork. The twisted trunk and outstretched arms add movement and drama.

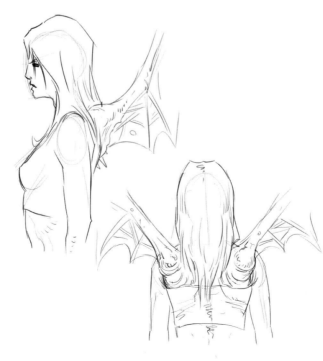

▲ Thumbnail sketch
Bat wings aside, the underlying structural core of the Manananggal is kept recognizably female and human from conceptual stage throughout.

Recreate this....

1 Pencil several rough sketches from different viewpoints and scan the chosen image.
2 Import scan into Painter IX at 300dpi. Rework drawing on a separate layer using "cover pencil." Flatten image.
3 Increase size to A3, then lay in colors using a separate "normal layer."
4 Flatten image, then add texture and shadows with the "multiply layer." Flatten and add another "normal layer" to add highlights.
5 Render the elements of the background and foreground.

SEE CREEP FACTOR **PAGE 31** ANATOMY **PAGES 24–29** FLESHING IT OUT **PAGES 36–39** ATMOSPHERE **PAGES 40–45**

▶ Finished art

The viewer's eye is drawn to the tearing waist—the focal point of the piece—then up the chest, across the wings, over the face, and along the curling tongue. Depicting the creature in purple against a green background (see page 28) sets up a dramatic and supernatural atmosphere (see pages 27 and 41). Textured highlights on the skin evoke a reptilian feel, and the pinkish highlights around the figure's silhouette lift it out from its background (see pages 42–45).

▼ Wing detail

Even though this feature could best be described as bestial, it has been adapted to the human female form. To make the wings more batlike, for example, the webbing would have to be stretched down to the legs, conflicting with the necessary break at the waist.

Signs of wear and tear and decay can be worked into the shoulder attachment and wing span.

Ghoul

As failed crops and widespread famine rocked the land, some humans turned to cannibalism, contracting a transmissible form of spongiform encephalopathy that caused the brain to decompose. Degenerating into ghouls, they gathered in hunting packs, whooping and laughing uncontrollably as they preyed on unsuspecting victims. Disgusted by the smell of fresh meat, they wait for the bodies to decompose before feasting on the flesh.

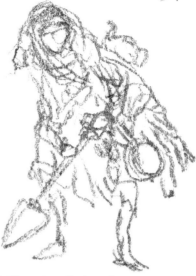

▲ Thumbnail sketch

Although the face is almost always the focal point, it is prudent to omit it at thumbnail stage (but not from your mind). Creating the creature's expression at thumbnail size is not only tricky, but slight variations can create a conflicting feature that gets in the way of how you really want your creature to look (see pages 22–23). This could prove distracting in the later stages.

▶ Props: wares

The harmless-looking equipment strapped to the hunched frame of the Ghoul represents one of the design's most intriguing aspects. Combined with a shovel and a satchel full of human body parts, these utensils confirm the Ghoul's active cannibalism. Remember that a design element can convey horror and be perfectly mundane!

▲ Sketch

Although the torn, layered rags may appear shapeless at first, the figure's underlying structure is important to the artist at all times. The garments may look piled on in a random manner but they overlap and weave in and out of each other convincingly. Make sure the various sections of cloth have a consistent crease. Notice charming details like the cooking gear and supplies hanging from the mountain of clothes, and the baby being cradled.

Recreate this....

1 Using a scaling grid, enlarge the thumbnail to a full-size sketch. Add detail appropriate for the size of the painting, then scan the image.

2 Import the scanned pencil drawing into Photoshop, set the "burn" tool to "highlights" and add shading to give form to the figure.

3 Place highlights using the "dodge" tool set to "midtones."

4 Add a new layer set to "soft light" and paint in colors.

5 Extra layers set to "multiply" are built up to create the grimy textures.

6 Place a paper or canvas background behind the character artwork.

SEE CREEP FACTOR **PAGE 31** ARTIST AT WORK **PAGES 50–55** PROPS **PAGE 37** COLORS **PAGE 28** DETAILS **PAGES 48–49**

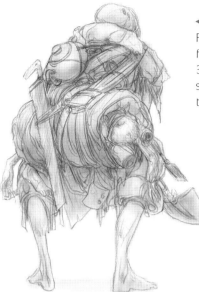

◀**Rear view**
From behind, the dominant design element is a gruesome hunk of human flesh draped around the back of the Ghoul's neck like a collar (see pages 36–39). Different domestic wares—a teapot, a saw, and a spade—can be seen poking through the tangled mass of belts, cords, and straps that bind the creature. They may look jumbled but they distribute the weight evenly.

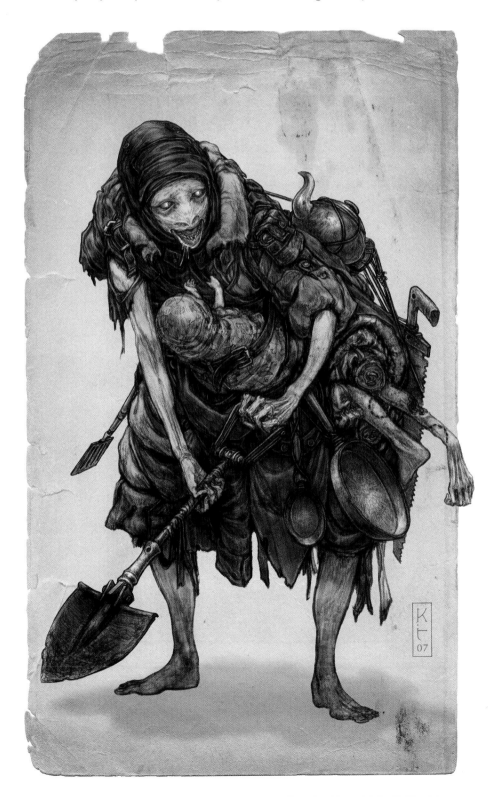

▶**Finished art**
Despite the various discolored earth-tone glazes over the mass of rags, each layer is carefully laid down individually. This level of attention has a cumulative effect that takes subtle hold as it progresses, making a vast difference to the final impression, and delivering a better concept of weight and depth as well as a pleasing patchwork pattern (see pages 50–55).

Lich

The Liches have roamed the plains between life and death for thousands of years. After a breakthrough in their dark art, they drank the elixir of immortality and initially seemed to age—but never died. Drawing power from secret magical sources, this race of alchemists now wanders the earth as one of the undead, summoning and taking over mortal bodies. These creatures stink of death and impart their chalice of knowledge to ambitious kings.

Recreate this....

1 Prepare a same-size pencil sketch on heavy tracing paper.
2 Transfer image from tracing paper to board.
3 Block in areas with warm colors until nearly complete.
4 Add glazes.
5 Blend and shape the color blocks, then highlight.
6 Scan in and save as a Photoshop file.
7 Clean up and adjust the colors using tools in Photoshop.

Spidery.

▲ Thumbnail sketches

These rough silhouette studies explore different skeletal frameworks in quick succession from which a final version gradually evolves (see pages 22–23). There is also the opportunity to experiment with the suitability of different props—canes, staffs, hats, and flasks. The cane, for example, becomes a central feature to support the Lich's hunched posture.

Personalized notes and symbols help remind you of any changes, modifications, and problem areas in your design.

Rotations

Flipping your sketch from left to right (in front of the mirror if you so wish) can help test the suitability of the same pose. Rotations are also useful for checking drape and lighting (see pages 50–55). Having someone model clothing for you, or even imagining what your character might wear, is helpful to your art.

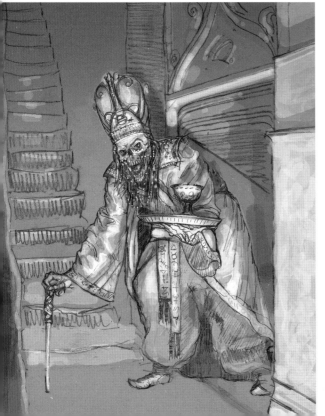

◀ Value study

Dark and light tones applied to the outline sketch give a fuller range of values (see pages 27 and 40–41). A midrange gray tone is chosen for the background to help make it recede and blend in with the figure. Many of the finer details begin to emerge and need to be negotiated. Elements addressed in earlier sketches demand full resolution before moving on to the final stage. The contrast between materials—specifically cloth and metal—starts to become apparent due to the application of value.

▲ Portrait

This head study is intriguing and disturbing because it fully shows the creature's face and teeth through a veil. No attempt is made to obscure the expression! The turban-like headpiece has been removed to reveal the shape of the head and keep the sketch small.

▶ Finished art

The chosen color scheme is one associated with royalty—a conscious decision here that reinforces the narrative. A brilliant mix of gold, purple, and turquoise offsets the luxurious garments (turban, stole, epaulets) and accessories (headdress, salver, chalice, rings, cane handle). The underground cavern-like setting with its narrow flight of steps is heavy with mystery. A red light projecting from the stairwell bathes the Lich's back with color, but does not distract from the face.

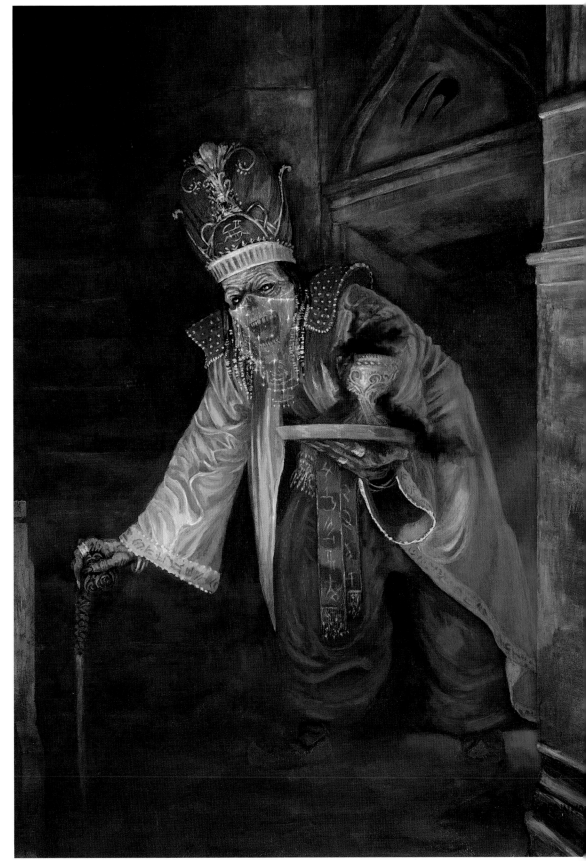

Undying Flagellant

Practiced since pre-Christian times, flagellation was not uncommon among the fervently religious. Incapable of real devotion and undeserving of heaven, the Holy Scourge brotherhood turned to this form of punishment as penance. These half-dead monks wander the land collecting alms and whipping themselves. They derive secret pleasure from their self-inflicted pain, a twisted path to piety that has robbed them of their mortality forever.

Recreate this....

1 Transfer the thumbnail freehand to a full-size sketch.

2 Finish up the details in pencil and scan in the image.

3 Import into Photoshop and add shading to the figure by setting the "burn" tool to "highlights."

4 Set the "dodge" tool to "midtones" and add the highlights.

5 Add colors to a new layer set to "soft light."

6 Lay a paper or canvas background behind the character artwork.

7 The cloud of incense is partially erased, so more of the paper texture and hue show through from below.

◀ Props: censer
A counterpoint to the more unpleasant torture implements in the piece, the swinging incense burner adds an element of elegant monastic ritual that reminds the viewer of the figure's origins. Practice drawing wisps of sweet-smelling smoke coming out of the perforated lid.

As the flail comes down across the monk's scourged back, it throws up flecks of skin and dust particles into the air.

◀ Sketch
A dynamic element such as the cat-o'-nine-tails is rendered as a slight blur with minimal detail. More focus is placed on the overall form of the object in motion. Details on moving objects can be more limited than on their static equivalents.

◀ Thumbnail sketch
The benefits of preparatory drawings include realizing a wave of sudden creative insight on paper as ideas spring to mind. Technical efficiency is not key here, so the quality of your thumbnail need not be great. Attempt to draw a particular section of your sketch from different angles. If this becomes too layered, work with your favorite pose. Notice the alms bowl on the ground.

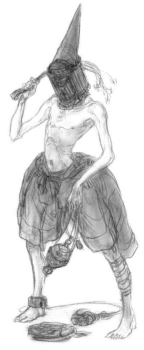

▶ Front view
Turning your character away from the viewer creates a sense of uneasiness because you fear what you cannot see. Only the most effective figures are capable of exercising similar amounts of interest from the rear as the front. Although a full-on presentation does reveal more information, this disclosure may remove some of the character's mystery (see pages 36–37).

SEE STORYLINE **PAGE 46** ATMOSPHERE **PAGES 40—45** PROPS **PAGE 37** POSES **PAGES 32—35** DETAILS **PAGES 48—49**

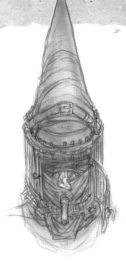

▲ Portrait

There is no face as such here, but perhaps this absence makes the helmet-cage all the more compelling and disturbing (see page 31). Masochistic and sadistic implications are at work here.

► Finished art

Grittiness and filth are major characteristics of the finished artwork as is the Flagellant's identity as a member of the clergy. Clothing and props must support this idea in the final art. The monk's skin appears bruised, wan, and distressed, but a slight blush reassures the viewer that he is in limbo as opposed to lifeless.

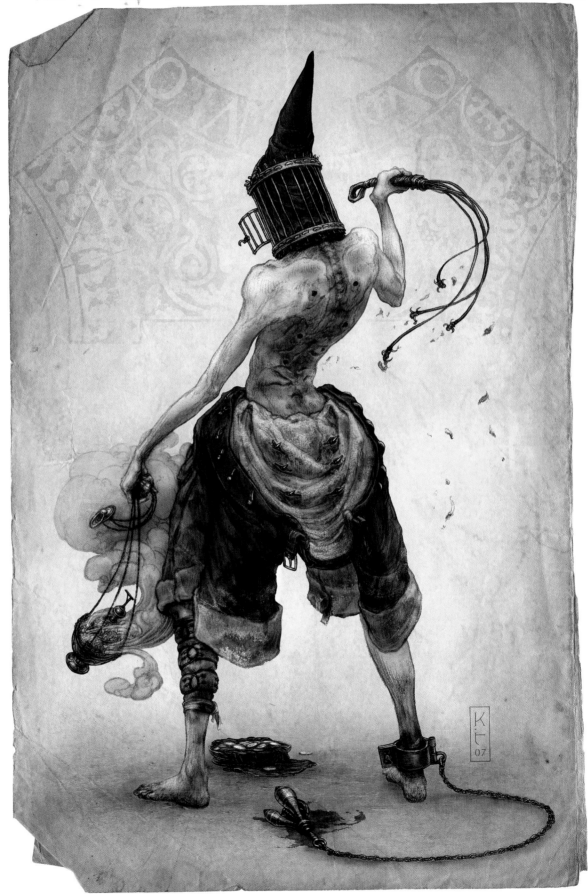

Jiangshi

Taoist wizards following Qing dynasty armies on military campaigns would cast rites over the fallen, beckoning the dead to rise and return to their hometowns for proper burial. On arrival, these poor souls often found their settlements razed to the ground. The inconsolable Jiangshi now haunt the length and breadth of China.

Recreate this....

1 Prepare several rough sketches from different angles.
2 Scan in the chosen sketch at 300dpi. Use "cover pencil" to rework in Painter on a separate layer. Flatten image.
3 Double the image size to A3.
4 Lay in the colors onto a separate "normal layer."
5 Flatten image. Add texture and shadows with "multiply layer." Flatten.
6 Add another "normal layer" for any highlights.
7 Add details, working on background and foreground elements with the "tapered oils 1" brush.

▼ Sketch 1

A detailed and successful sketch could easily be carried forward to the finished stage. As the details and major elements start to take shape, it becomes apparent that a different perspective may improve the overall design. Notice how little linework can still convey large amounts of visual information.

▲ Sketch 2

The same creature is sketched but in a more dramatic pose this time and on a platform from which to make the most of its elongated limbs (see pages 32–35). This is the initial stage of the finished artwork.

▼ Thumbnail sketch

The initial creative direction was for a long-legged creature with large feet. With most of the fine detail omitted, including any weaponry, the focus is on core physical structure. Basic linework renders form and goes over itself to cement any decisions made (see page 20).

▶ Hand detail

Hand studies are useful for coming up with believable hand poses that suit your creature. Notice how the withered skin wraps tightly around any remaining flesh. Larger-than-life hands with gnarled knuckles and exaggerated talon-like fingernails help give your work a more horrific feel.

▶ Props: saber

The Jiangshi are fallen Chinese infantry, so any props should shed light on their lifestyle or occupation before death. These soldiers would not have fought with high-end weaponry, so this flat shot of a battered sword is the perfect choice.

SEE ATMOSPHERE **PAGES 40–45** SETTINGS **PAGES 46–47** PROPS **PAGE 37** COLORS **PAGE 28** DETAILS **PAGES 48–49**

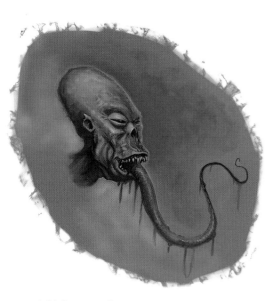

▲ Value study

The Jiangshi's elongated, vine-like tongue was first sketched in loosely as a possible concept. In the high-contrast tonal study above, however, the detail is carefully rendered and becomes central to the creature's identity. The detailed portrait also presents the elongated bulbous head with distorted Asiatic features from a different perspective (see page 31). This preparatory painting establishes the dominant livid green color scheme of the final artwork.

▶ Finished art

The Jiangshi is presented against a loosely painted misty background with a barely visible flight of steps leading up. The tongue is thicker and more exaggerated, while green highlights in the upper right-hand corner of the piece add complexity to the ambient hues and help to separate the monster from his backdrop. The fiery eyes, rectangular defensive armor plates sewn onto padded cloth, and blood-dripping sword add visual flair.

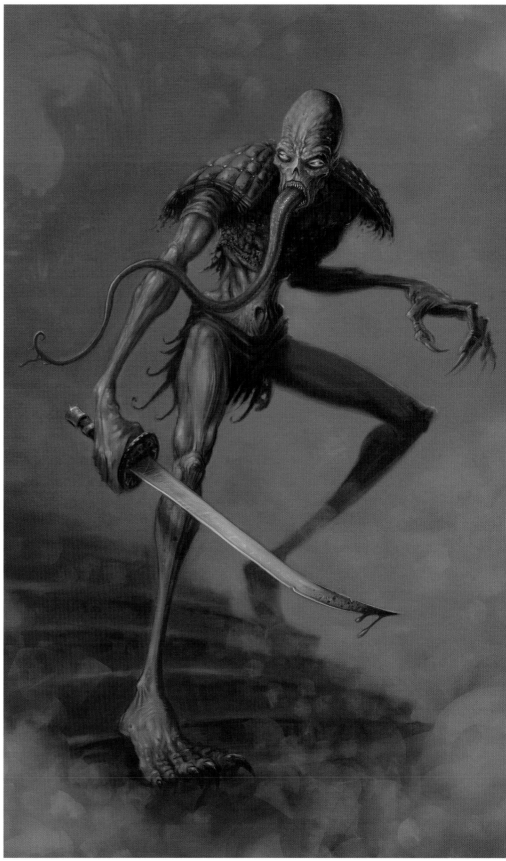

Wendigo

Although some in the higher echelons of the Aztec empire hailed the coming of the deity Quetzelcoatl in the form of a white man, others believed the visitation to be simply that of a mortal from a foreign land. Driven by apocalyptic visions, elite cadres of panther warriors began hunting down the pale-skinned impostors, degenerating into frenzied murderers and eating the flesh of victims to gain strength. Depraved and twisted, the Wendigos eventually massacred the conquistadors in a bloody flesh-harvest!

Recreate this....

1 Scan the sketch and import into Photoshop as a new layer.

2 Block in the main color masses.

3 Now use the "dodge" and "burn" tools to indicate the main shadows and highlights.

4 Adjust the "hue" values for the creature's costume and the skin to ensure there is enough contrast between them.

5 Add colors to a "soft light" layer.

6 Lay a paper or canvas background behind the character artwork.

▼ Thumbnail sketches

The creature's dynamic gesture is used to good effect in the initial creative direction. Although the anatomy is twisted, the overall physiognomy is human. Notice how reptilian features can be achieved by elongating, distorting, and deforming human facial traits (see page 31).

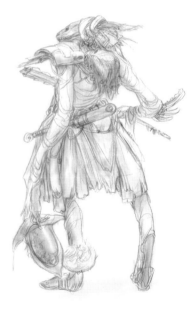

▲ Rear view

The Wendigo's dynamic stance consists of legs wide apart and sandaled feet splayed in a "V" formation. The hanging arm of the Wendigo may be obscured in the final piece but is in full view here. This gesture speaks volumes about the creature's nature: a compassionless brute with the trappings of a warrior.

▲ Sketch

The elaborate design of the Aztec armor (including the feathered headdress) is fundamental and cleared at an early stage. Although the underlying garment is fairly simple, the tunic is decked with complex symbolism and jewelry, including an armor plate with a feline face. The Wendigo is wearing the skin of a victim over his own—the hands, feet, and face can be clearly seen.

SEE STORYLINE **PAGE 46** PROPS **PAGE 37** COLORS **PAGE 28** DETAILS **PAGES 48–49** POSES **PAGE 32–35**

◀ Props: trophy

The upturned conquistador helmet overflowing with blood is now being used by the Wendigo as a drinking vessel. Though not strictly a part of the creature's character design, the European relic serves as a powerful narrative element.

◀ Props: club

Comprised of two slats tied together with shark's teeth anchored in the grooves, the Wendigo's weapon is based on an original spiked Mesoamerican mace edged with sharp pieces of obsidian. The item finishes in a sharp point like a spear.

▶ Finished art

The final painting is defined by a lively color scheme that echoes those of Mesoamerican cultures (see page 12). The piece conveys key features of Aztec life and aesthetics—extensive amounts of jade jewelry, gold, precious stones, feathers, and the element of human sacrifice.

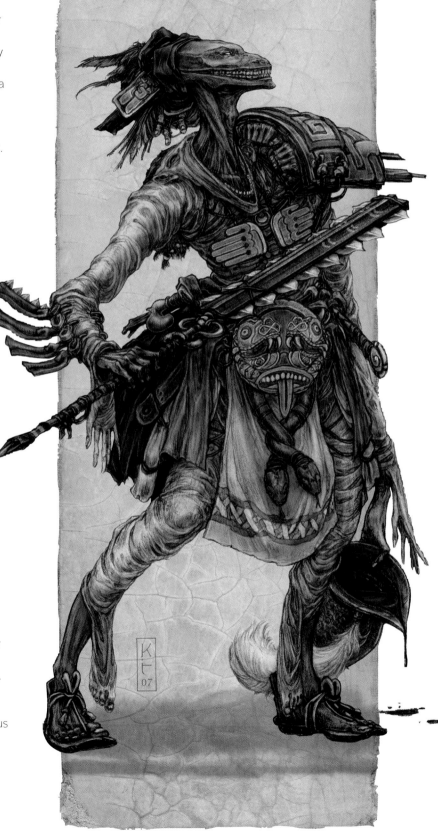

Medical Abomination

This modern-day Prometheus from Victorian literature was pieced together from a patchwork of criminal cadavers by a renowned physician. Discarded by his maker in disgust, and reviled by all who laid eyes on him, the creature became confused, enraged, and embittered about why he was brought into a world that despised him.

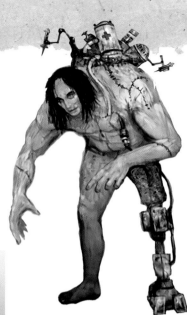

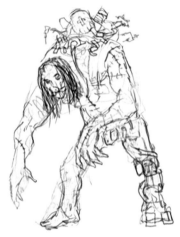

▲ Thumbnail sketch

The concept of a mutilated human patchwork of surgical parts and industrial machinery is established before the preparatory sketch is even finished. The face, a major point of focus, is addressed immediately. The desired result is a monster who appears to be alive despite severe surgical and engineering errors (see page 15).

► Sketch 1

To change the pose and add in new details, simply place tracing paper over an enlarged version of the thumbnail sketch or transfer digitally to a computer screen (see pages 22–23). The rough background helps ensure unity between the character and its surroundings.

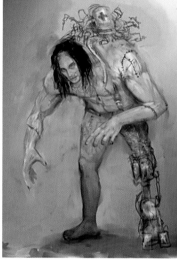

▲ Sketch 2

Larger than sketch 1, sketch 2 has been digitally enlarged. There is more detail here. Defining features have been pulled out, leaving less important aspects sketchier. Notice the emerging mismatch between the creature's appearance and the long hair wig (see page 38).

► Sketch 3

The addition of several mechanical components transforms the look of the creature. The quality of your overall art should not suffer from weaker details lagging behind, so make sure that you refine them. In this instance, the background issue must be resolved by first addressing the overall impact of the character.

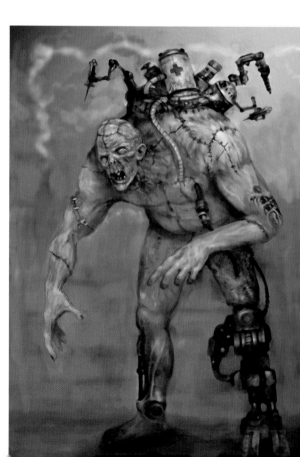

Recreate this....

1 Scan thumbnail sketch and import into Photoshop and enlarge.
2 Get rid of the white background. Use "dodge" and "burn" to paint in the shadows and highlights.
3 Adjust "hue," "saturation," and "value" to create a basic color scheme.
4 Save image and import into Painter.
5 Use "watercolor" to refine colors.
6 Use "paintbrush" for details.
7 Use "glow brush" for highlights.
8 Save and re-open in Photoshop.
9 Define highlights and shadows with the "dodge" and "burn" tools.
10 Refine with the "paintbrush" tool.

SEE FLESHING IT OUT PAGES 36–39 ANATOMY PAGES 24–29 PROPS PAGE 37 COLORS PAGE 28 DETAILS PAGES 48–49

►**Finished art**

The painting stage involves finalizing your design and bringing out your character's unique trademarks (see page 27). In this instance, the artist concentrates on refining several visual details to bring out the surgical sutures of the skull and skin, the muscles and tendons growing over the mechanical parts, the tubes bypassing the creature's collapsed veins, the self-contained medical kit and pumps, and the syringes used by the monster to stop himself from rotting.

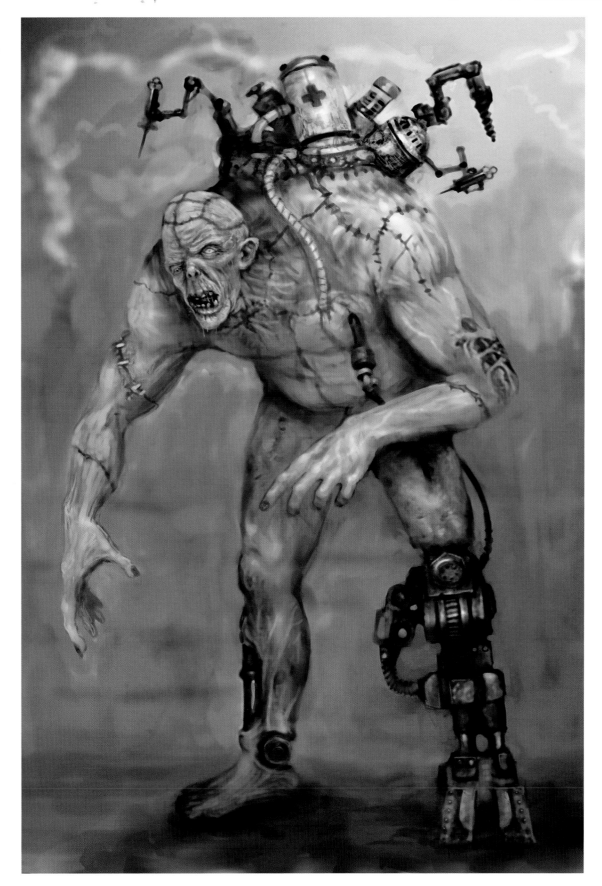

Necromancer

Madame Theodosia, the last in a long lineage of necromancers, grew up in the tradition of raising the dead. After learning of her barrenness, she vowed to give birth to something—be it dead or alive—and strapped on a pressurized steel womb to trap souls in a gestating entity known as "The Collect."

Recreate this....

1 Make a scan of the full-size sketch and import into Photoshop as a new layer.

2 Clean up the artwork and apply any necessary changes in Photoshop's "levels" or "curves."

3 On a layer beneath the sketch, lay down the main color masses.

4 On the next layer up, sketch in the main highlights and shadows using the "dodge" and "burn" tools.

5 Keep highlights minimal and muted for a softened effect.

6 Add a base layer of textured paper or canvas to add interest to the painting.

7 Place a paper or canvas background behind the character artwork.

The position of the fan naturally guides the eye of the viewer toward the face.

◀ Sketch

An air of eerie reservation characterizes this design. In keeping with the somber drapery of the gown, it is crucial for this drawing to explore a refined bearing for the figure that will then offset the hard-edged midsection metal protrusion. Do not worry about the values of your finished drawing just yet: simply rework problematic areas (see page 38) and apply glazes to lighten the linework later on (see page 54).

▶ Value study

This high-contrast tonal sketch shows how the steel womb fits into the torso of the Necromancer and how much space it occupies. More details about the drapery of the cloth are apparent here with the veil offering an unsettling suggestion of necromantic ritual.

The softer the fabric, the more bends and curves are necessary to show realistic movement.

Head-on view

Side view

▲ ▶ Thumbnail sketches

The more symmetrical head-on view is replaced by a side angle which shows the creature's graceful feminine form in profile. These more defined proportions present the steel stomach for the first time.

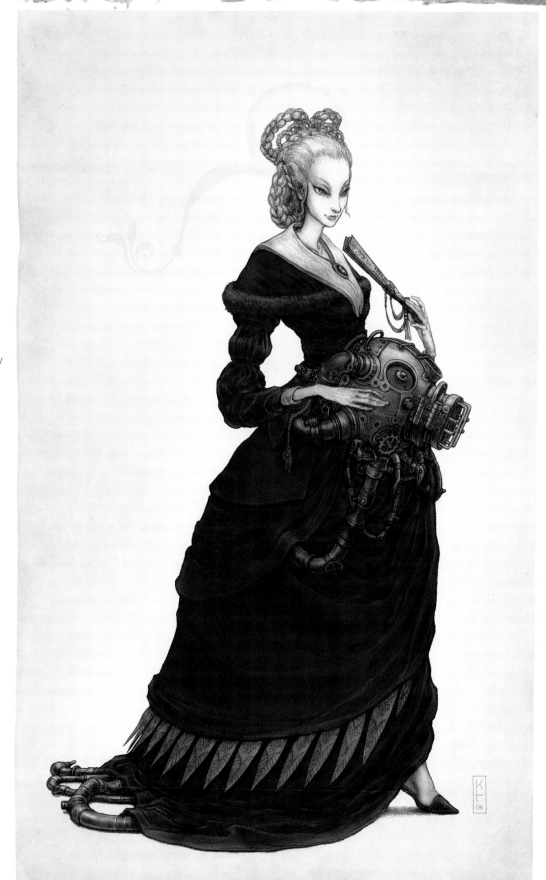

Well-placed highlights really bring metallic surfaces to life.

▲ Props: steel womb

The gestation contraption, shown disconnected and suspended above, shares an uncanny resemblance to a Victorian deep-sea diver's helmet. Borrowing objects from a specific historical period and combining them with new and often unexpected elements helps to create ingenious fantasy details (see pages 12–15).

▶ Finished art

The decision is made in the final stages to flip the figure. The need for this compositional change (see page 38) becomes apparent once the piece has been framed. The sparse color scheme is stark and moody—a contrast of alabaster skin against black cloth and shiny metal.

Black Shuck

This ghostly black dog is said to roam the Norfolk, Essex, and Suffolk coastlines of England. As the amalgamated spirit of all animals crushed under hooves or carriage wheels, the Black Shuck is rarely seen by humans. The apparition causes horses to bolt, toppling their riders or causing tragedy at crossroads. Eyewitnesses describe a beast with burning eyes and jowls pulled back in a grimace.

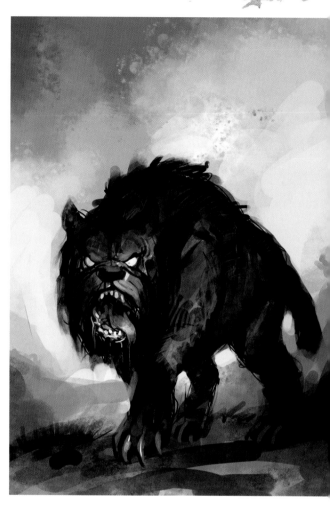

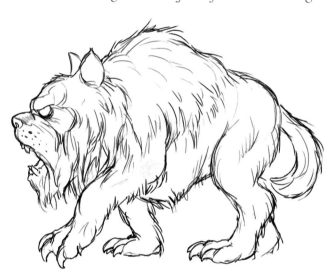

▲ Side view

This profile sketch was chosen to kickstart anatomy and form, not function as finished art. The creature's canine form has been distorted to evoke an unsettling, supernatural feel: the ridge of the back is raised and hunched, the face and ears given a batlike quality.

▲ Value sketch

Add shading to your linework to bring the focus back to form and stance. Make the animal's silhouette distinct with a defined body and black limbs. Allow the background path to convey atmosphere, so show a hint of foliage or tufts of scrub.

► Front view

A monstrous, imposing shape is key. Add heavy, matted fur to accentuate muscular bulk and soften the edges to suggest a ghostly aspect. Although straightforward, this full-on sketch begins to address the animal's appearance in the final artwork. If a dynamic pose is hampering your creature's development, choose a simpler pose to explore specific forms before moving to a more interesting pose (see pages 36–39).

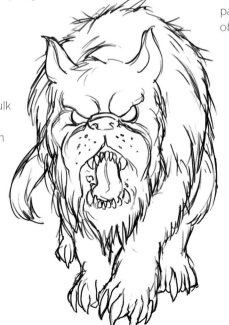

Recreate this....

1 Scan in the pencil rough, then copy the Photoshop file in a new layer set to "multiply" with 50% opacity.
2 Add basic color on the background layer, which shows through the semi-transparent layer above.
3 Flatten image.
4 Refine the painting on a single layer, working from dark to light tones.
5 Paint in the fine details.
6 Add highlights.
7 Tweak the contrast as appropriate.

SEE POSES **PAGES 32–35** SETTINGS **PAGES 46–47** DETAILS **PAGES 48–49** COLORS **PAGE 28** ATMOSPHERE **PAGES 40–45**

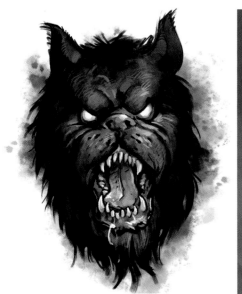

▲ Portrait

Without the expressive quality of props or hands, the animal's face is crucial in communicating evil intent. The head is developed almost to completion in order to fully explore a convincing expression before the final artwork begins. Ragged silhouetting suggests the texture of short fur without having to draw in the individual hairs.

▶ Finished art

A pose showing slow, deliberate movement is carried through to the final painting. Seen from the front, it suggests that the apparition is advancing toward the viewer. The paws suggest a gradual, menacing advance and the dribbling saliva looks gory. The heavy brows are knotted and the open mouth reveals large fangs and a lolling tongue. The mouth and eyes against the black bulk become the focus of the piece. The eyes have no pupils so a frontal view is needed to suggest the creature is staring out of the page.

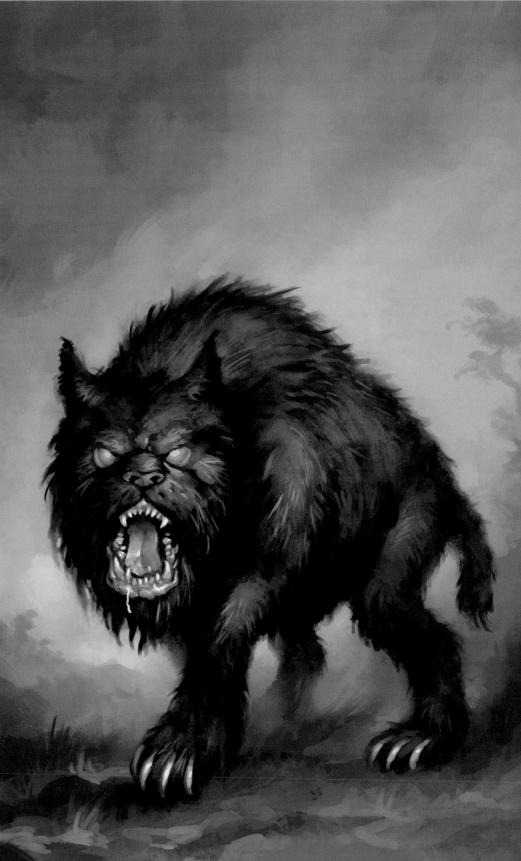

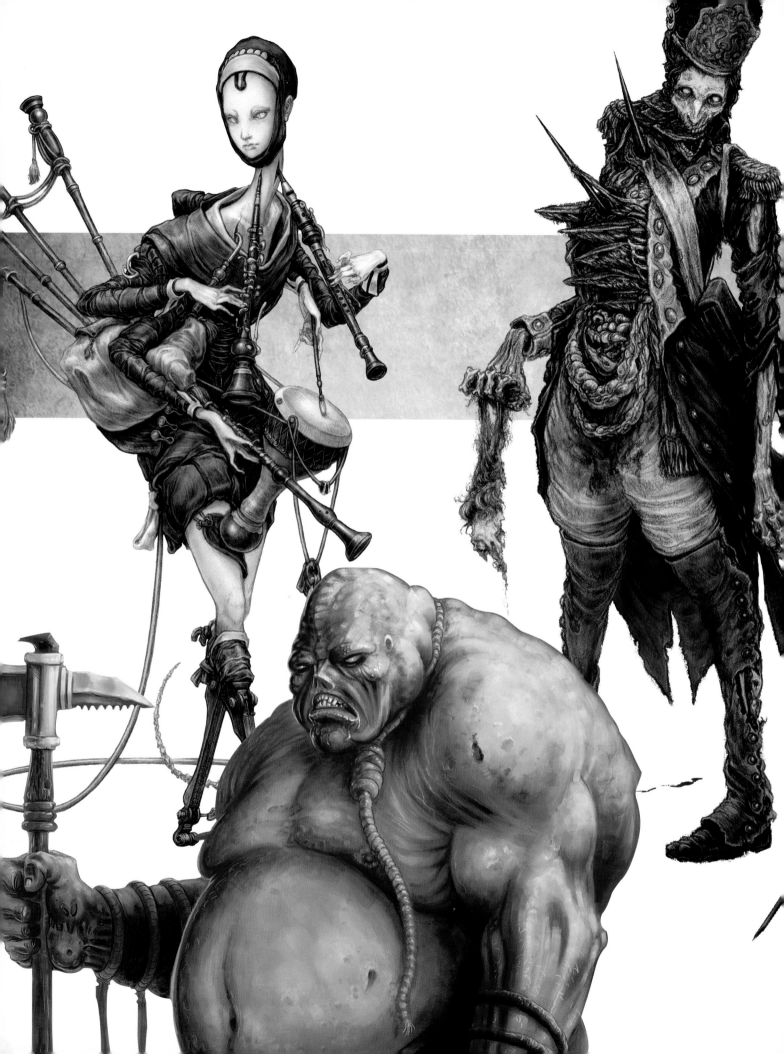

The Walking Dead

These characters of the undead move around freely—zombies, skeletons, and mummies—as the restless remains of once-living creatures that have since been reanimated by spiritual or supernatural forces. Their undead existence is often passed on as a curse or a disease. Some examples are even the byproducts of grotesque genetic permutations following contamination.

Fungal Zombie

Having lost communication with their commander during the eastern campaign, an entire infantry division backed forth into uncharted marshlands. Written off as lost or deserters, they caused great horror and shock when they returned to attack and infect their compatriots with a deadly virus, saliva, or blood.

Recreate this....

1 Scan the full-size sketch and import as a new layer in Photoshop. Keep the linework straight around the edges.
2 Set the "burn" tool to "highlights" and "dodge" tool to "midtones" to add in shadows and highlights respectively.
3 Create a new layer set to "soft light," adding colors as a transparent glaze with the "paintbrush" tool.
4 Make small adjustments to the finished piece using other Photoshop tools.
5 Place a paper or canvas background behind the character artwork.

▼ Sketch

Major elements, including the fringes of the uniform and limb proportions, are introduced in this preparatory drawing (see pages 22–23). The lopsided, lurching posture is carefully studied, as are later intricate details, dressing up this ghostly military figure. These linear decisions—the blueprint for the creature's anatomy—guide the viewer's eye and play off the proportions and placement of various elements against one another.

Remember to only use soft pencils for loose, exploratory sketching.

Heavy, high-contrast shading creates the texture of fur on the helmet.

Avoid laying down lines that are too heavy.

This very unusual stance is captured at thumbnail stage.

▲ Thumbnail sketch

This thumbnail contains much rougher linework than any of the finished art (see pages 20–21). Details like the pigeon-toed stance and the eye-catching sharp points of the protruding bayonets are key elements even in the initial development stages.

▲ Value study and rotation

To present an alternative view of the figure, simply place your original artwork on a lightbox and place a piece of paper over it. Quickly sketch in the new proportions over the old pose (see page 38). The tonal sketch shows the two muskets in detail and gives a three-dimensional understanding of the soldier's awkward stance. The position of the two bayonets is such that it is possible for them to remain in a relatively stable position as the zombie shuffles forward.

Shading lines need to conform with the direction and plane of the weapon's surface.

▲ Props: muskets

The few visible sections of the weapons have to be recognizable and reasonably accurate, so photographic reference material is essential (see page 37). In this instance, a flint-lock musket has been slightly shortened from a real grenadier's weapon for practical reasons. While this slight change is not particularly important in one-off pieces, it is a major decision when part of a larger scene where muskets are a recurring prop, for example, and must be consistent.

▶ Portrait

This detailed profile shows the zombie rushing headlong toward its victim— tongue extended, mouth pulled back in a biting gesture, and fungus erupting from its mouth.

▶ Finished art

The zombie's costume follows the style of the militia from the Napoleonic Wars. The muted color scheme complements and enhances the drained skin tones and viscera of the figure (see page 28). The regal colors of the uniform are dulled and obscured by layers of filth and decomposition. Very little edging is cleaned up in the final painting, leaving a ragged variance to the outline of the undead, especially around the tattered and frayed clothing.

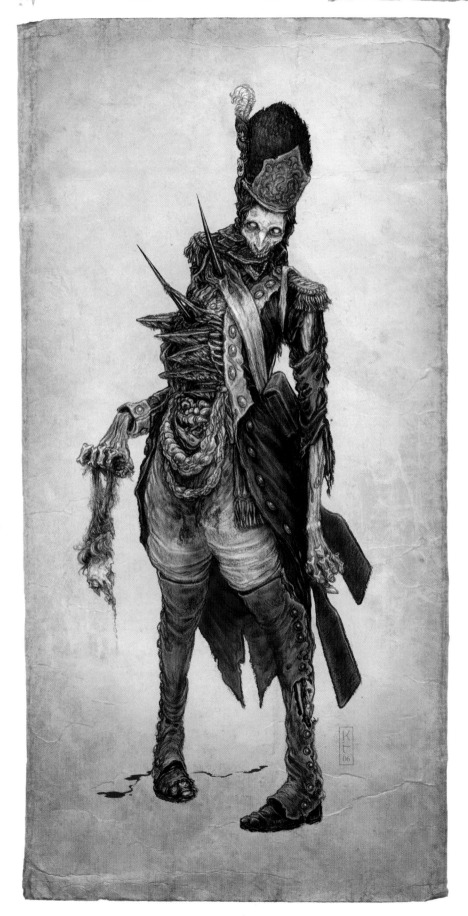

Mummy

In ancient Egypt, the priests of Anubis developed a mummification process for the tomb guards of the Pharaoh to protect his royal person after death. It was believed that if brain and skull were kept together in a jar, the body would be able to rise from the dead and perform the tasks it did in life. A special caste was groomed from birth to be ready to die and be mummified with their ruler.

▶ Thumbnail sketch

Decide whether or not to have warped body proportions early on at concept stage. This drawing shows major departures from conventional anatomy in the lengthened limbs, rounded skull, and broadened shoulders. Creative decisions like grafting the weapon to the forearm must be thoroughly tested before moving to the final artwork (see pages 22–23).

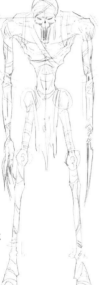

▼ Side and rear views

These close-up portraits are key because the head is such a major point of focus. The side view shows a thin, bony neck connecting to the head and torso. Notice how the jaw is not fully attached but hangs down in a permanent gape. The rear view makes the spine and back muscles clearly visible.

▼ Props: stump blade

The binding detail is key for showing how the weapon attaches to the mummy's forearm. The look and position of the blade must be credible: it must not look as if it could pull out, bend, or—worse still—snap off!

▲ Props: kopesh

Make sure that this variation on an Egyptian cutlass fits comfortably in the hands of the creature.

Recreate this....

1 Scan in chosen viewpoint image in high resolution at 300dpi.
2 Import into Painter and rework using "cover pencil" on a separate layer. Flatten image.
3 Double image size to A3. Lay in colors on a separate "normal layer."
4 Flatten image. Add texture and shadows on a new "multiply layer."
5 Add highlights on another "normal layer."
6 Add fine details on the same layer.
7 Use the "tapered oils 1" brush to work on background and foreground.

▶ Sketch

In this drawing, the mummy is shown charging out from the Pharaoh's tomb. Although the floor is flat, raised paving stones inject vitality to the scene. Notice how the dust clouds are laid in as basic linework, even though they will be painted over in the finished art (see pages 20–21).

▼Props: canopic jar

The design of this vessel is one immediately associated with ancient Egyptian funerary practices. It confirms that the mummy's major organs have been removed from the body but were buried with it.

▶Finished art

In the final painting, dirty browns, yellows, and greens describe a dusty, airless setting. Sores and boils (see page 28) have been added to the mummy's skin for visual interest and the bandages from the initial sketch look neater. Using the same uniform value tone for the rear leg and deep shadows conveys a sense of mystery and impending doom through the haze (see page 40). Notice how robust both weapons look now.

Pripyat Beast

When the secondary nuclear reactor exploded, it spewed forth a torrent of radioactivity. The inhabitants of the surrounding towns survived just long enough to dig mass graves for their dead. The unprotected and ultimately doomed clean-up volunteer force sent a flurry of distress signals reporting the emergence of jumbled beasts from underneath piles of bodies. These creatures, sickening amalgamations of people and livestock, varied in appearance.

▼ Sketch
Economical linework (see pages 20–21) executed successfully conveys the remains of a liquidator torn in half, with his lower portion lodged in one of the beast's maws. The sketch is fluid and essential—nothing more than an outline to give the impression of weight and structure. This loose outline introduces details that will need to be finalized in later stages.

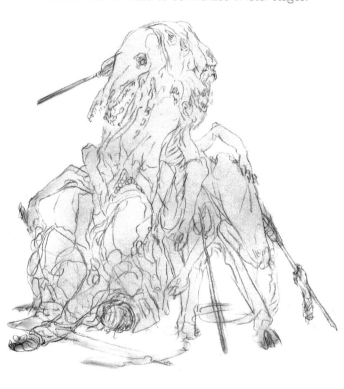

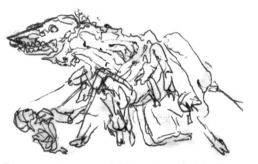

◀▲ Thumbnail sketches
The wretchedness of the beast is well conceived, but this first conceptual thumbnail is a little overworked. In the second attempt, the design is too static, making the beast look like a crawling invalid. Notice how some of the multiple limbs are superfluous here. Do not let amorphous qualities dictate a loosely connected physical structure. Think of entwined and confusing shapes as an additional layer over a more conventional framework.

▶ Vertical mouth
A dominant feature is the grotesque maw set sideways into the chest of the beast. In the final art, this detail is partially obscured by the victim being devoured. This detailed study shows that these jaws have a relatively simple structure. A radical change in scale and anatomy can transform a normal feature into something truly disturbing.

Recreate this....

1 Enlarge the thumbnail to a full-size sketch, enhancing the details to give you more to work with.
2 Scan the sketch and import into Photoshop as a separate layer.
3 On a layer beneath the sketch, lay down the main color masses.
4 On the next layer up, sketch in the main highlights and shadows using the "dodge" and "burn" tools.
5 Delineate and jaggedly blend in the mottled hues of skin, meat, and fur.
6 Build up the details on the topmost layer using the Photoshop tools that suit you best.

SEE STORYLINE PAGE 46 ANATOMY PAGES 24–29 COLORS PAGE 28 PROPS PAGE 37 MUTATIONS PAGE 28

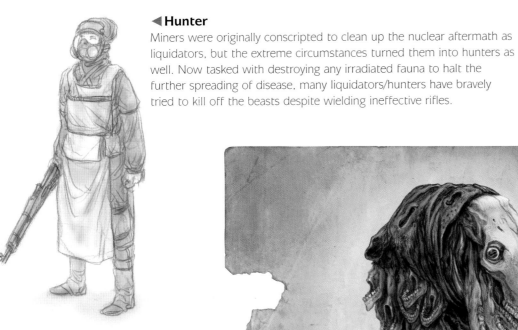

◀ Hunter

Miners were originally conscripted to clean up the nuclear aftermath as liquidators, but the extreme circumstances turned them into hunters as well. Now tasked with destroying any irradiated fauna to halt the further spreading of disease, many liquidators/hunters have bravely tried to kill off the beasts despite wielding ineffective rifles.

▶ Finished art

The beast is presented as a grotesquely fused combination of farmers, livestock, and farming equipment. Projections of bone burst forth from many key parts of the creature's anatomy as though they had grown and been reshaped faster than its amassed flesh could keep pace with (see page 31). Protruding farm implements, such as the pitchfork, hint at the desperate attempts to put a stop to the rampage.

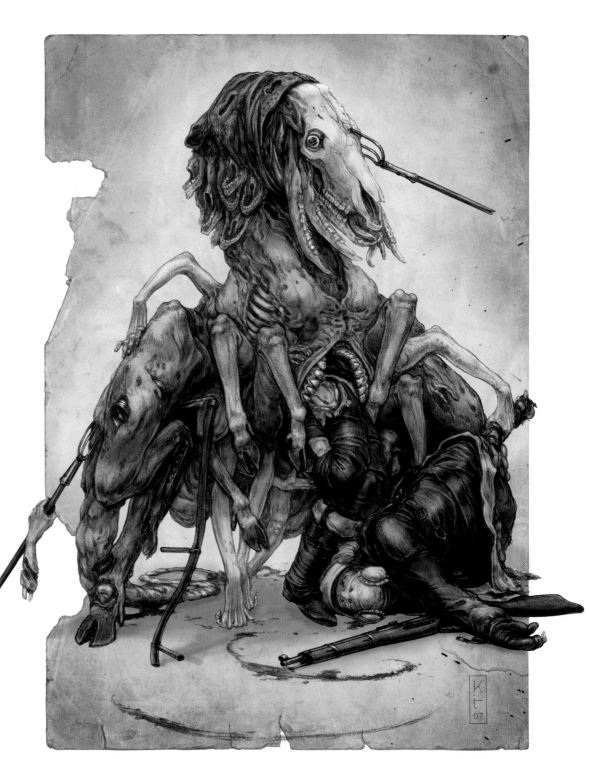

Revenant

Criminals executed alongside innocent men can sometimes trick the spirit world while on the threshold of death into granting them permission to possess a corpse as the spirit is despatched to the afterlife. Physically bloated, with mental faculties that have long since rotted away, the Revenant rise up from their graves to revisit the living, their sadistic impulses spurring them to bloody action.

Recreate this....

1 Transfer your thumbnail sketch onto a piece of gessoed masonite. As your confidence grows, try to do this freehand.

2 Block in the background shapes then, starting with the darker colors, build gradients toward the lighter colors.

3 To the main figure, add darker hues first, then build up the range of hues, working toward highlights.

4 Give a sense of depth by blurring objects that are further away.

5 Adding a blue cast to background objects gives a sense of distance.

◄ Sketch

The snapped noose around the neck and the wrist cords underline the creature's massive bloated form. Compare this sketch with the finished version and note that the image has been flipped and the moon removed as it distracted from the Revenant's face (delicately balanced against the head trophy). The source of illumination in the setting is now unspecified. While it is nighttime, the light seems otherworldly.

▲ Thumbnail sketch

The Revenant's strength is not entirely supernatural so its physical proportions need to convey this idea. Think of the base to this brutish creature as a triangle superimposed over the outline of the body with the legs balancing out the widest girth.

▼ Side and rear views

These detailed alternative views show the creature's neck disappearing into its massive body bulk. For the sake of consistency—ignore this tip if you are still exploring the nature of your character—make sure that you keep facial expressions the same in between the rotations (see pages 36–37).

◄ Props: axe

After returning to life, the Revenant will pick up any weapons they find nearby—in this case, an executioner's axe. The prop is carefully chosen to work well with the creature conceptually.

▼ Value study

Shocking elements must be supported by the narrative (see page 46). The execution theme here results in the inclusion of a graphic severed head as a central feature prepared through a tonal sketch.

► Finished art

In the final painting, the pallor of the rotten flesh is striking, coupled with areas where the skin has developed lesions. The only fresh blood visible—that of the victim—is on the axe blade. Notice how the pale hue of the severed head differs from the creature's skin tone. This difference points to an unearthly element in the Revenant: not a shambling corpse perhaps, but certainly a host for some dreadful, potent force (see page 31). The graveyard setting is thematically consistent and suitable. Everything you have learned about producing undead artwork is applied here with an added emphasis on blank stillness.

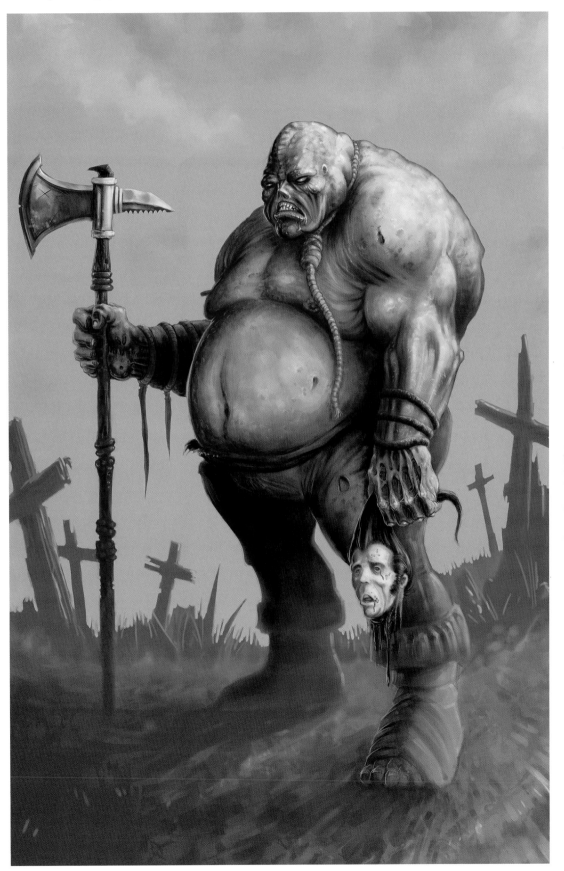

Skeleton Warrior

Ancient battlefields and places where mass-scale carnage has taken place gradually become haunted with the countless fallen dead. The remains of these undead skeleton warriors are haunted and rise up to reenact past wars. If their activities are disturbed by the living, however, the presence of a new foe causes great commotion and a sudden spark of vitality courses through their ravaged forms, urging them to attack and kill.

Recreate this....

1 Begin with a skeleton in a lolling stance and work up its outfit.

2 Lay down several thumbnail sketches and explore different poses, armor, and weapons.

3 Prepare a loose sketch, then transfer to the final board.

4 Use paint to block in areas of light and shadow.

5 Paint in the finer details until the skeleton form begins to emerge.

6 Add small finishing touches such as the scuffs on the armor to areas of interest such as metal and bone.

7 Tighten up the loose paintwork behind the character.

▶ **Silhouette thumbnails**

This sketched sequence of shadow outlines shows a variation of poses rather like a cartoon strip. Notice how decorative details, such as the horns on the helmet, and more compositional elements, such as the viewing angle, are shifted slightly with each thumbnail (see pages 22–23). Produce as many possible designs for selection as you can. Viewed together, thumbnails can be compared against each other to reveal conceptual successes, problems, and challenges.

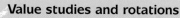

Value studies and rotations

A sequence of well-executed rotations tests your character from different angles and helps to pinpoint the finer details of the artwork. The warrior's skeleton was never intended to have a large range of movement—the focus is on developing tonal studies for the armor. Storytelling elements such as the arrows piercing the body, the ball and chain, and skull belt are introduced to express the damage and decay defining the piece.

SEE DECAY **PAGES 30–31** ARTIST AT WORK **PAGES 50–55** FLESHING IT OUT **36–39** POSES **PAGES 32–35**

▶ Finished art

The final painting is a floating illustration that fades into the white of the page. The color scheme (page 28) contains several cool hues—fully supporting the feel of a character long dead—with any hint of warmth or life extinguished from it. Remember that it is acceptable to appeal to the viewer's suspension of disbelief for the sake of aesthetic persuasion. The bulging eyeball, for example, was included simply for artistic reasons and is carefully handled to minimize a potentially glaring conceptual problem for the viewer.

Cobbled Scald

The Swedish court was scandalized when a talented Scald, renowned across Scandinavia for his unparalleled musical skills, revealed himself to be a woman. After a swift execution, the embarrassing event was banned from polite conversation. The creature returned to court, and was dispatched numerous times, but she kept coming back to life, her body strangely repaired as if by a tailor. In time, the court embraced the eerie presence as a beloved tradition.

Recreate this....

1 Transfer the thumbnail to a full-size sketch.

2 Finish off the details in pencil and scan in the image.

3 Import into Photoshop and shade with the "burn" tool set to "highlights."

4 Highlight with the "dodge" tool set to "midtones."

5 Add colors to a "soft light" layer.

6 Use the appropriate Photoshop tools to smooth over any roughness in the textures and ensure a gentler effect.

7 Place a paper or canvas background behind the character artwork.

The Scald's legs, composed of two string instruments worked into the shins, play music when they rub together.

▶ Thumbnail sketch

The delicate cut of the Scald's dress is already apparent in these early conceptual stages. A restrained approach to costume is therefore encouraged to stop it from competing with other aspects of the design. The intricate, intertwining arrangement of arms and instruments adds an elaborate decorative element.

▲ Sketch

The Scald's serene, Madonna-like face is the primary focus as the viewer's eye is drawn up the long, swan-like neck. Her calm and gentle demeanor colors the piece, softening the more gruesome characteristics. The addition of the monkey skeleton assistant tied to her belt is introduced at this stage.

SEE ANATOMY **PAGES 24–29** ARTIST AT WORK **PAGES 50–55** FLESHING IT OUT **36–39** PROPS **PAGE 37** POSES **PAGES 32–35**

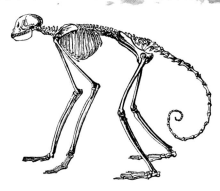

▲ Monkey skeleton

The animated monkey assistant is a relatively straightforward affair: this primate skeleton on a leash collects coins in a tiny port glass as added amusement after the Scald's performance.

▶ Props: bagpipes

This heavily modified instrument held under one of the Scald's left arms resembles Irish or Scottish bagpipes. The mouthpiece is the element that deviates most from the original inspiration. Notice how it enters the trachea with a fishhook barb and anchors to the lungs (see pages 48–49).

▶ Finished art

A major motivation in the final painting was maintaining a sense of elegance in a character that could easily have become grotesque. The bizarre and macabre aspects (see page 31) are offset by decorative and attractive details designed to enthrall the viewer.

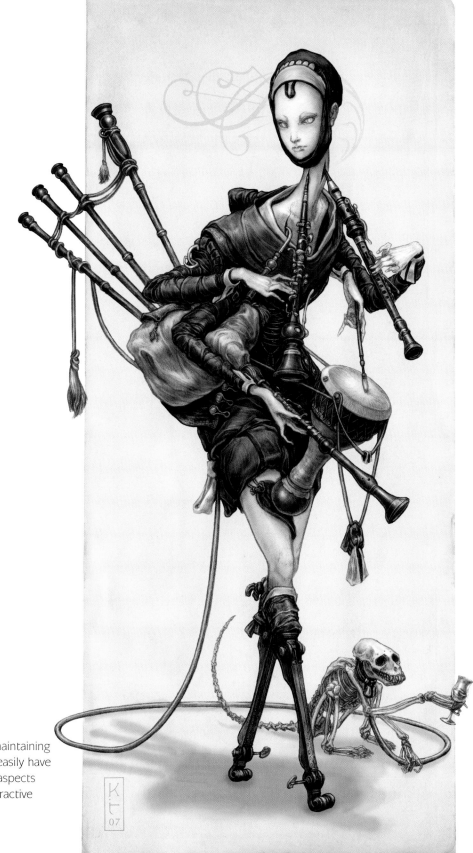

Draugr

In Norse mythology, the Draugr were corporeal undead living inside Viking tombs. After the Great Wars, survivors buried their dead underneath mounds. The victorious few now rest for all eternity as the numerous defeated are unable to find peace. The Draugr inhabit these restless corpses, awaiting the day when they will be unleashed upon the world.

Invent a fitting background story for your creature. Try to imagine the sort of experiences that could have shaped and affected its appearance.

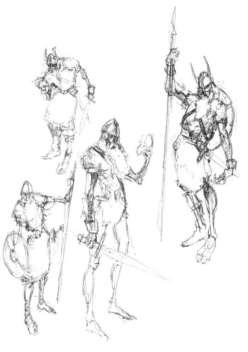

Recreate this....

1 Enlarge thumbnail to a full-size sketch by means of a scaling grid directly onto gessoed masonite.
2 Add extra detail and form to the enlarged sketch.
3 Apply burnt umber as a loose under-painting using stiff bristle brushes.
4 Use small, sable brushes for more detailed work.
5 Add colors to the underpainting.

▶ Thumbnail sketches

Explore your ideas at thumbnail stage (see pages 20–21) and experiment with using different mediums. Draw loosely as you manipulate shape and value to find a balance in your work. Notice how some preliminary thumbnails are more historically accurate than the finished art.

▶ Sketch

After exhausting all possible ideas at thumbnail phase, produce a clean and tight line drawing. Use historical references if you wish to add depth (see pages 12–15). Your familiarity with the "feel" of your research will be apparent in the legibility of your work. In this design, creative liberties have been taken for aesthetic and thematic reasons. More specifically, the Vikings never wore horned helmets but there is an apocryphal association here, and the added visual interest justifies the use.

Value studies and rotations

Life drawings are essential for mastering form and a good preparation for sketching characters from different angles. Refining details during these later stages means that earlier visual references may come in handy so don't throw anything away! Notice how these three Viking Zombie rotations also function as value studies. The smallest details have been considered. Remember that the Draugr has just risen from the damp soil of a battlefield ground after centuries of burial (see page 30). It makes sense, therefore, to have wasted skin and muscle, and a chainmail armor that is moldy and rusty.

SEE DETAILS **PAGES 48—49** FLESHING IT OUT **PAGES 36—39** ATMOSPHERE **PAGES 40—45** PROPS **PAGE 37**

▶ Finished art

Look beyond the obvious and try to find intriguing ways of using shape, value, and color to enhance your character. When bringing a "zombified" creature to life, darker values, muted colors, and drooping shapes are a safe bet. These additions help take your design to the next level. Notice how these values and form begin to come out in the final piece, projecting an even deeper mood. The use of sickly yellows and oranges (see page 28) gives the impression of a barren, airless atmosphere that suits the background narrative perfectly (see page 46).

Mechanized Corpse

On the anniversary of the Treaty of Münster, the Council of Illuminati unveiled their plans for global domination to the world. Leaders scoffed at the audacity of a stateless authority threatening the good of mankind, but their initial dismissiveness turned to horror when countless regiments of mechanized soldier-corpses began invading all countries. These ground troops formed the vanguard for the usurpation of nation after nation, and defense troops suffered huge losses in attempting to stem the inexorable invasion of mutilated cyborgs.

Recreate this....

1 Scan the thumbnail sketch, then import into Photoshop as a new layer.
2 Delete the white background. Paint in the shadows and highlights with the "dodge" and "burn" tools.
3 Adjust "hue," "saturation," and "value" to create a basic color scheme.
4 Save image and transfer into Painter.
5 Use the "watercolor" tool to refine the colors. Render any details with the "paintbrush" tool. For highlights, use the "glow" brush.
6 Save and re-open in Photoshop.
7 Define highlights and shadow areas with the "dodge" and "burn" tools.

▶ Sketch

Rigidity is essential in a creature built from mutilated human remains trapped in a robotic frame, that then attaches to a machine-gun mechanical-hip emplacement (see page 37). Notice how the metal binding constricts the human parts. The old organic legs are cinched up out of the way—they have not been removed simply because of laziness on the manufacturer's part.

▶ Thumbnail sketches

The first attempt is too conventional, but the second reworking successfully brings together the core design idea of a militaristic cyborg zombie. These early detailed preparatory sketches test the viability of having mechanized parts grafted onto a human foundation (see pages 22–23). Notice how the addition of mechanical legs is carried through to the final art.

SEE ARTIST AT WORK **PAGES 50–55** POSES **PAGES 32–35** ANATOMY **PAGES 24–29** MUTATIONS **PAGE 28**

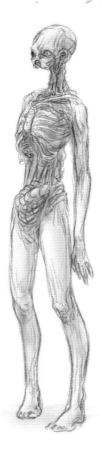

◀ Anatomy

Although much of the host's original human anatomy is intact, the jaw and midsection are absent. Notice how the artist gradually dehumanizes the frail human core as the more dominant mechanical components are worked in (see page 31).

▶ Props: grenade

It can be a good idea to modify objects you have referenced earlier in your work. Combining several of these items maintains a sense of plausibility as you introduce strange new concepts. Notice how this grenade (which is shaped like a potato masher) has been wrapped in a coil of barbed wire that adds to the effect of disembodiment.

▶ Finished art

Drab military details and a sparing use of black dominate the final color scheme with occasional skin hues showing through (see page 28). The heavy damage, extensive wear and tear, and pitiful state of the zombie host reflect an inhuman brutality (see pages 42–45). A communications pack strapped to the corpse's back feeds it instructions.

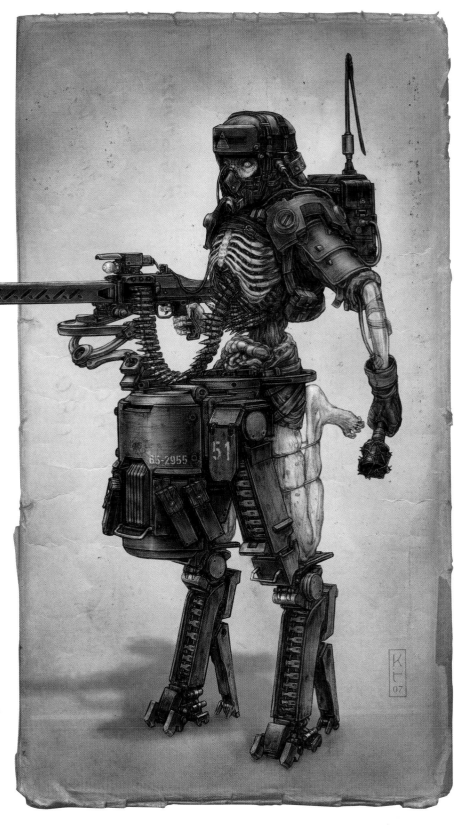

Necrotic Colossus

These towering bulks of reconstituted and animated flesh were once a common sight on the Siberian steppes. These terrifying siege engines have since been decommissioned and adapted for more benevolent cultural rituals, following a prolonged period of peace. The Colossus now functions as a nomadic funeral temple in the wake of tribes and caravans on the move. Formerly driven by a whip-cracking beastmaster, it is now pulled by two yoked pack animals.

Recreate this....

1 Make a scan of the full-size sketch and import the result into Photoshop as a new layer.
2 Clean up the artwork and apply any necessary changes in Photoshop's "levels" and "curves."
3 In Photoshop, set the "burn" tool to "highlights" and shade.
4 The strong shading on the cylindrical tower form is cleanly laid in on its own layer.
5 Set the "dodge" tool to "midtones" and highlight.
6 Place a paper or canvas background behind the character artwork, erasing around the character to clean it up if necessary.
7 Use any other appropriate Photoshop tools to make small tweaks and adjustments to the finished piece.

◀ **Thumbnail sketch**

With this creature, many complicated elements are devised at concept stage, so the thumbnail needs to be large and very detailed. Notice the two stylized idols held in each of the creature's hands to announce that this elephantine hulk is now a moving temple. Iron out any major kinks in the design at this stage. Check any disparate elements against one other before moving on to the next stage (see pages 22–23).

▶ **Sketch**

Notice that much of the tangled mass of the Colossus has been loosely rendered (see pages 20–21). Drawing isolated parts in more detail would only distract from the sketch's overall impression at this point. Fine detail will follow through in the final stages, but it is important to avoid muddying the sketch's overall impression. Your drawing process has to be balanced so do not get carried away.

▲ **Props: yoke**

The oxen steer and incite movement in the mindless Colossus. The yoke is left plain to accentuate the domestic adaptability of the monster, so there is no conceptual reason to elaborate on this basic design.

The huge scale of the Colossus means that the lines of stitches weaving across its skin are extremely faint.

▲ Portrait
The strange, elephantine facial structure becomes clearer from this perspective (see page 28). The tusks are really extended canines on the lower jaw. The brow is smooth and mostly featureless, and the eyes are sunken and blank.

▶ Finished art
The oxen help convey the massive scale of the Colossus, and the stiffness in structure is exaggerated to assist with this; curves and bulges in the creature's anatomy have been drawn out over a greater distance. The attention to detail is exquisite. Witness the grave plates hanging from the creature's waist that bear the names and dates of the tribe's deceased.

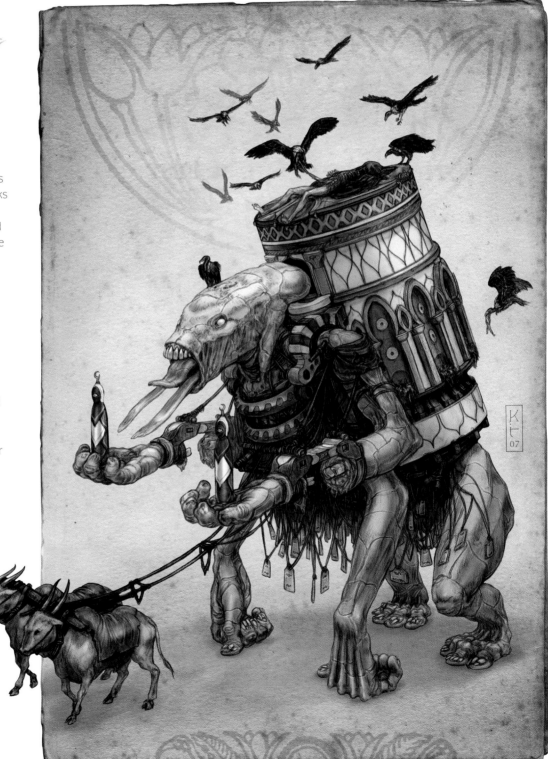

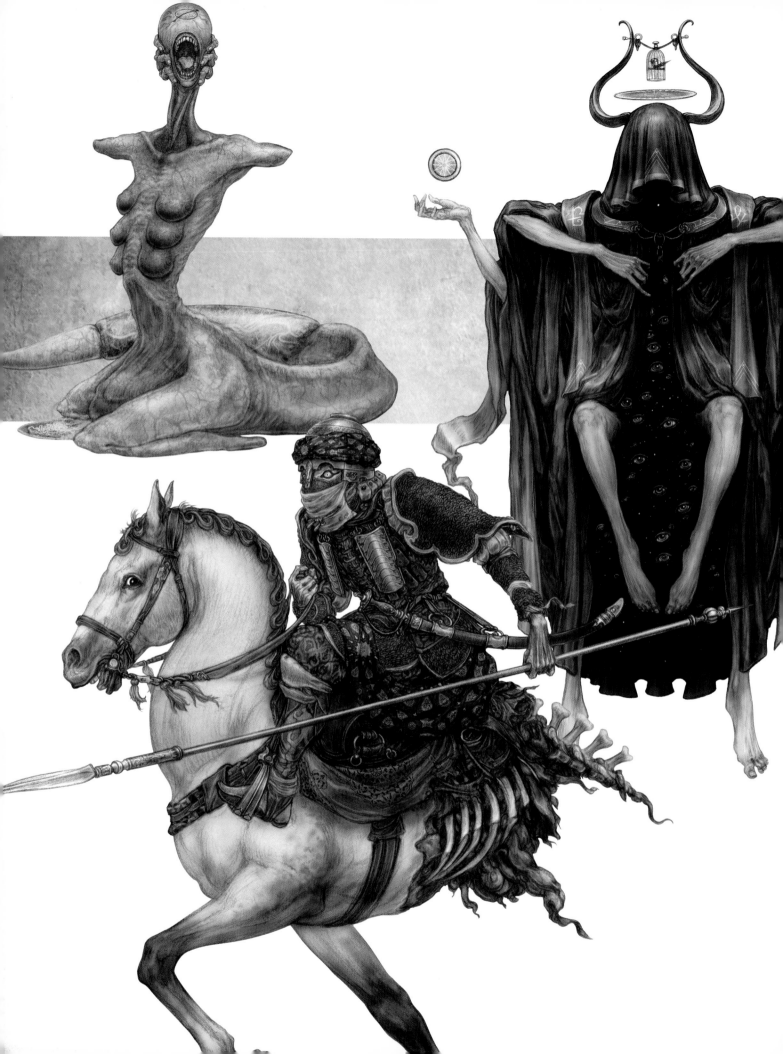

The Ethereal

With incorporeal entities such as apparitions, specters, and ghosts, the spirit is trapped in the earthly plane through sheer willpower in a body that, though now intangible, will often reflect the one occupied in life. Hence a ghostly warrior might appear riding his galloping steed or a lantern spook emerge through swirling wisps of fragrant incense. Some essences are so mysterious they even transcend the boundaries of matter.

Vampire

In popular folklore, a vampire is a nocturnal ghoul who awakens at night to drink the blood of the living. Stories abound of anemic travelers at countryside inns witnessing their wayward companions being consumed by the occupants. They describe comely peasants serving them ale with a smile that twists when night falls. Fleeing under daylight, these storytellers point to blank spots on maps and inns with names like "The Shepherd's Drained Stock" and "The Cock and Sanguine Crook."

Recreate this....

1 Transfer the thumbnail to a full-size sketch on gessoed masonite.
2 Draw a loose background for the final painting.
3 Begin adding color, starting with the darker color, then the midtones, and finally the lighter hues.
4 Work on the main figure in the same way, adding darker hues first before working up to the highlights.
5 Paint in finer details and highlights with a finer brush.

▼ Thumbnail sketches

The direction of the design is established at conceptual stage. Keep your sketching style loose and exploratory (see pages 20–21).

A reworking of the same pose from the original portrait clearly identifies the direction of the final art. Revisiting the same sketch twice can be useful in confirming the effectiveness of a finalized design that is ready for execution.

This presentation stance is too aggressive and contrived for a vampire who was once a peasant girl.

This angle allows the figure to adopt supernatural movement as if she were floating (see page 29).

Value studies and rotations

With floating characters, you must remain aware of where the legs and feet are at all times during the rotations (see pages 36–37). In tonal sketches, notice how clothing can enrich the end result. The heavy fraying and tatters of the dress not only give clues about the vampire's condition and age but add aesthetic flourish. Added shading gives the darker-than-expected skin tone of the final artwork and confirms major changes in hue.

SEE POSES PAGES 32–35 FLESHING IT OUT PAGES 36–39 STORYLINE PAGE 46 DECAY PAGES 30–31

▶ **Finished art**

Undead subjects are ideal for challenging any artist to experiment with deep, dominant shadows (see page 27). Inject mood into your final painting for a darker, more desperate vampire. The blood dripping from the mouth onto the bodice is a nice horrific touch. The dark rings around the eyes give the creature a wide-eyed stare and the chosen color scheme—dry browns and yellows—evokes crusted blood, caked mud, and dirt (see page 28).

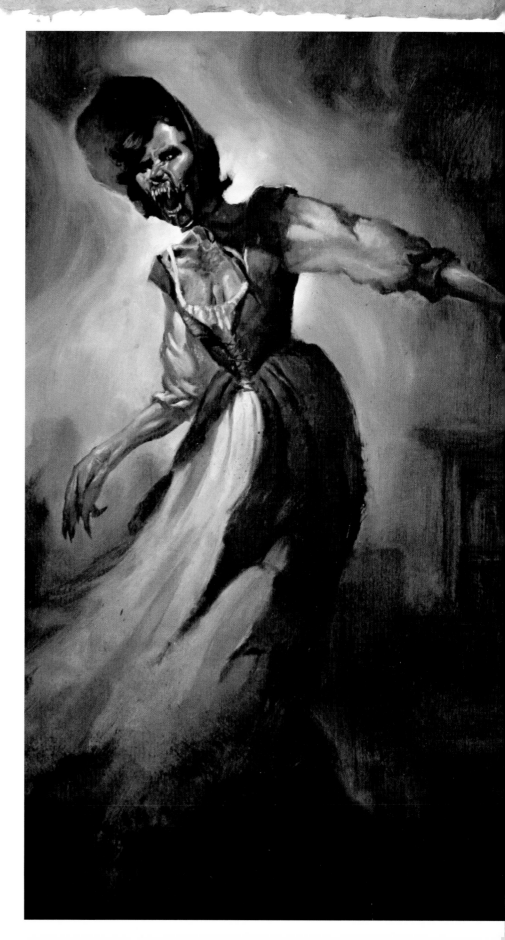

▲ **Portrait**

A detailed and focused sketch of the Vampire's face makes an effective starting point for the rest of the artistic process and is key for expressing personality and impact. Notice how the hair and clothing frame and accentuate the expression (see pages 40–45). The bonnet's curve and shadow lend aesthetic support to the design's focal point.

Lilin

This twisted offspring of Adam and Lilith (his wife before Eve) is as old as the earth. Capable of effective disguise, human settlements are plagued by its presence which sows distrust and confusion. The Lilin carelessly gives itself away by lingering on without any signs of aging. Ships, for example, have been found lost at sea, all of the crew dead by their own hands with just a single woman alive on board, strangely unshaken by the ordeal.

Recreate this....

1 Scan the full-size sketch and import it into Photoshop as a new layer.

2 Clean up the artwork and apply any necessary changes in Photoshop's "levels" and "curves."

3 On a layer beneath the sketch, lay down the main color masses.

4 On the next layer up, sketch in the main highlights and shadows using the "dodge" and "burn" tools.

5 Lay on the complicated patterns running across the skin on individual layers set to "multiply."

6 Add a base layer of textured paper or canvas to add interest to the painting.

▶ Thumbnail sketches

This preliminary drawing shows a more elaborate design with two eerie angelic forms on either side of the central figure. It soon becomes apparent, however, that these secondary characters are clashing with the sparsity of the central design, robbing it of visual dominance (see page 38).

It is often effective to have strange designs or unusual elements floating around characters of a mystical nature.

◀ Sketch

The Lilin's creature design is not very elaborate and hinges on a specific treatment that must be executed well in later steps. It it is tempting to introduce more elements but avoid this in the interest of a sparser, more focused creation. Artistic restraint will prevent your character from becoming visually overloaded.

▲ Props: crown

Originally imagined as a circular halo, the corona evolves into a cage-like iron cube to imprison the mind of the figure. Avoiding the conventional route after an initial concept has been developed can help to create unexpected props (see page 37).

SEE CREEP FACTOR **PAGE 31** POSES **PAGES 32–35** ANATOMY **PAGES 24–29** COLORS **PAGE 28** DETAILS **PAGES 48–49**

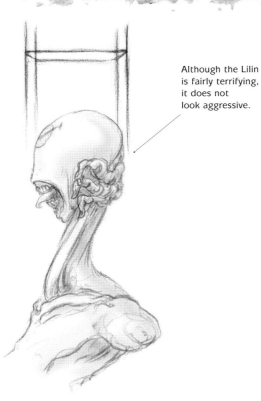

Although the Lilin is fairly terrifying, it does not look aggressive.

▲ Portrait

Even though the design presented here is quite stiff, be conscious of how the Lilin moves and twists from different angles. This side view features the creature's head tilted down, but in the finished art it is tilted up. Notice how the bizarre "halo" is suspended over the face.

▶ Finished art

The viewer's inability to guess the character's environment is intentional because the Lilin is truly undefinable. Presented in a dreamlike way, notice how the arms and legs terminate in stumps that originate from a time that predates even the forces of nature (see page 29). The creature faces the viewer—but not in an engaging way—with a mouth cavity ringed by wriggling fingers (see pages 48–49).

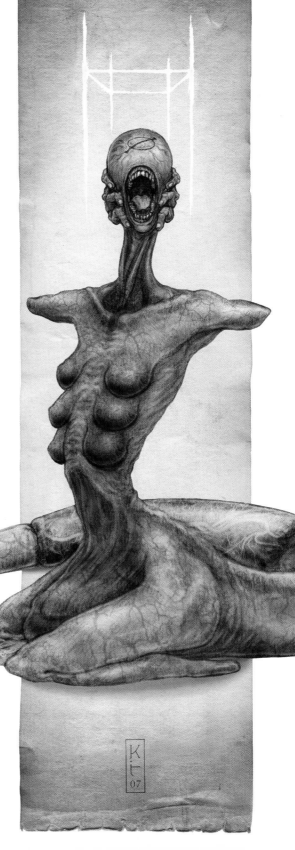

Vetala

The wraithlike Vetala from Hindu mythology dwell in trees and, unlike vampires, inhabit human corpses by day. Over time, they shapeshift into forms that suit their predatory nature. Humans are driven mad by their loud gibberish which, though unintelligible, contains truths not meant for human ears.

▼ Anatomical detail

You may want to sketch an anatomical study of a bat's wing. Layer several knocked-back images of flesh faintly outlined around the skeleton to show the inner structural detail. Other detailing could show the musculature obscured by heavy fabric or armor.

Recreate this....

1 Work up an inverted hanging batlike figure, sketched as if suspended from a branch.
2 Transfer sketch to final painting board.
3 Lay down a sickly yellow layer, leaving white borders all around.
4 Lay down earth tones over the initial yellow undercoat to establish areas of light and shadow.
5 Use a deep brown tone and black to define the creature's musculature.
6 Add sparing applications in pale hues as highlights to bring out more detail.

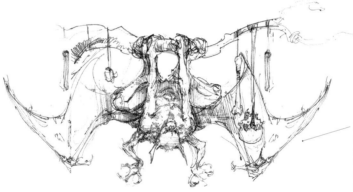

Bat references dominate the design from every angle—especially the chosen pose which shows the winged creature hanging upside down from a tree branch.

▲ Sketch

The central influence of this design was obviously the bat. Sometimes it is useful to pinpoint a specific source of inspiration (see pages 12–15) that can then be shoehorned into your work. The aesthetic benefits of working with imagery that fires your imagination can far outweigh any drawbacks.

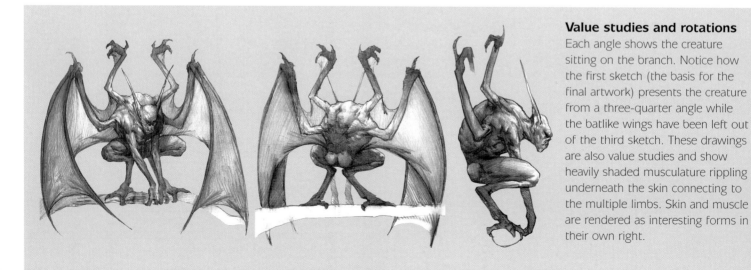

Value studies and rotations

Each angle shows the creature sitting on the branch. Notice how the first sketch (the basis for the final artwork) presents the creature from a three-quarter angle while the batlike wings have been left out of the third sketch. These drawings are also value studies and show heavily shaded musculature rippling underneath the skin connecting to the multiple limbs. Skin and muscle are rendered as interesting forms in their own right.

SEE CREEP FACTOR **PAGE 31** POSES **PAGES 32–35** ANATOMY **PAGES 24–29** COLORS **PAGE 28** FLESHING IT OUT **PAGES 36–39**

▲ **Finished art**

A dirty, sour yellow hue silhouettes the Vetala, exaggerating the vast dominance of its wings. Integral elements such as skin color were chosen during the initial stages. For the sake of uniformity, the bones dangling from the branch are not rendered in grays and whites, but in the same deep browns.

The Collect

In a fluid-filled, pressurized steel womb fitted onto a female Necromancer, souls are captured, stored, and condensed after death, until enough life force is amassed to create a unified entity known as "The Collect." This infinite collection of eyes hovers in the reaches of the stratosphere, overseeing the earth and influencing world events. As humanity lurches from one disaster to the next, the souls of the dead rise up in large clouds. The Collect drifts through them, absorbing more souls into its fold and growing ever stronger.

Recreate this....

1 Scan the sketch and import in Photoshop as a new layer.
2 Block in the main color masses.
3 The darkness deep within the folds of the fabric is strongly laid in before any shading begins to ensure that everything works with the dramatically dark patch.
4 Now use the "dodge" and "burn" tools to indicate the main shadows and highlights.
5 Add colors to a "soft light" layer.
6 Add a base layer of textured paper or canvas to add interest to the painting.

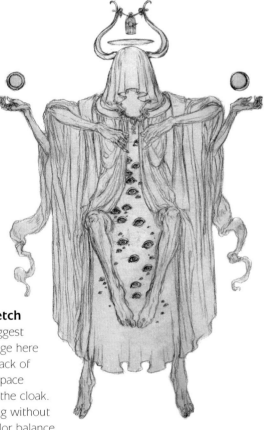

▲ ▶ Thumbnail sketches

In keeping with such an ethereal subject, the thumbnails are very loose (see pages 22–23); the design a muddled overlap of cloth and limbs. No matter how fractured the elements become, everything needs to be linked even if by visual inference only.

▶ Sketch

The biggest challenge here is the lack of black space within the cloak. Working without this color balance can create problems with the visual hierarchy on the page. Notice how in the final version the eyes shine out from a field of inky blackness, although at this stage, they are only floating dark spots in a white space. You can modify your design to include large dark areas.

► Props: caged bird

The birdcage suspended between the curved Viking-like horns of the Collect adds unexpected vulnerability. This delicate detail is out of place, imparting a perplexing aspect to the entity and supporting its strange and unearthly nature (see page 29).

Incongruous elements such as a trapped bird add complexity and an unearthly quality to the overall piece.

The sun and moon hang above the palms of the figure's outer arms.

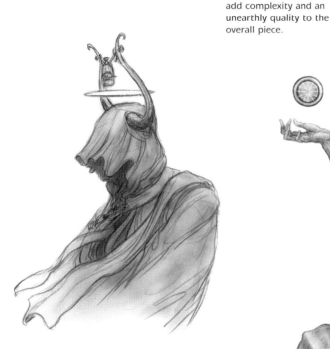

▲ Portrait

The draped, flowing fabric shifts and conforms to the force of unknown currents. It billows one moment, hangs still the next, the multiple constellation of eyes peering out from the folds of fabric. The emptiness within must be carefully rendered to work from multiple angles. Nothing should protrude, otherwise the effect of invisible volume may be compromised.

► Finished art

The final piece is more sinister than other undead creations. Conventionally "dangerous" details such as weapons are avoided because they detract from the desired effect. The final painting with its muted color scheme and still, calm atmosphere presents The Collect as though it were suspended in fluid (see page 34).

Yakshini

In a dark reworking of the classic Hindu myth, Yakshini are fairy spirits who possess the bodies of the dead and venture forth into human communities to wreak havoc. First appearing as tantalizing, voluptuous women, cracks in the façade soon reveal decaying flesh underneath. When these fickle beings take flight, their seemingly preserved forms will suddenly collapse before your very eyes.

Recreate this....

1 Prepare a pencil sketch and transfer the image to a board.
2 Block in areas with the main colors.
3 Add tones to give form and substance to the figure.
4 Work up details on the clothing with a fine brush.
5 Scan preliminary painting and import into Photoshop.
6 Clean up and adjust the colors.
7 Use Photoshop and Painter to add highlights and details.
8 Clean up with the "stamping" tool in Photoshop.

Group your thumbnails together for a close comparison but make sure they are not too cramped on the page.

▲ Thumbnail sketches

Despite the original story having roots in Hindu mythology, a Middle Eastern influence is evident from these silhouetted drawings. Adapting a character to specific cultural influences can, once filtered through your own style and taste, develop into a unique set of stylistic elements.

◀ Value studies

With form already established, use tonal sketches to quickly lay down patches of light and shadow. Identify the best source of lighting. If you decide to play with shadows, keep the illumination consistent throughout your work. Save any detailed drawing for the later stages.

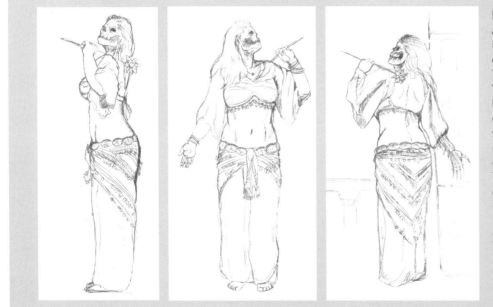

Rotations

As part of the creative process, it is important to test your character from different angles (see pages 36–39). The rear view works best for the Yakshini and a loose balcony background is laid down. These directional manipulations create surprising areas of interest and unexpected views to help you depict any character convincingly. They test the appeal of your design decisions. If problems arise, this is the moment to resolve them. Do not feel you have to repeat elements that you did not like from your thumbnails in your rotations.

SEE DECAY **PAGES 30–31** ANATOMY **PAGES 24–29** POSES **PAGES 32–35** DETAILS **PAGES 48–49** SETTINGS **PAGES 46–47**

▲ Props: lotus flower

The lotus flower works well as a decorative element because as a universal emblem of beauty it counterbalances the more macabre details of the piece. A preparatory tonal sketch firms up its visual impact before it is included in the final painting.

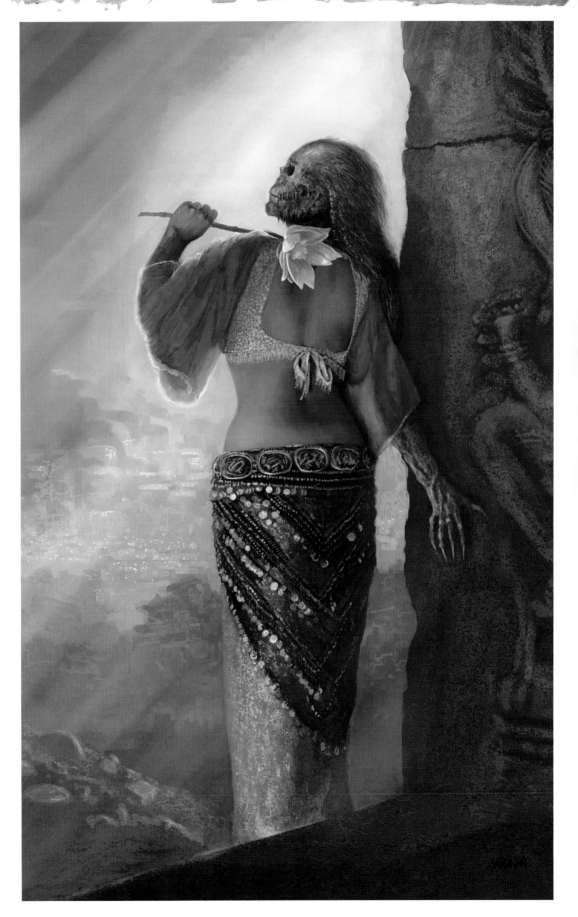

▶ Finished art

The Yakshini's facial features are silhouetted against the full moon (see page 31) and the light source is coming in from the upper right-hand corner of the piece. This somewhat "romantized" approach to an undead character shows how a wide variety of tones can be imposed onto a single subject. The contrast between sexy, bare flesh and decomposing, wasted parts creates a tense, visual dynamic that really works to create mood.

Apollonian Wight

Groundbreaking experiments for extracting energy from the vacuum of the sun were being carried out by astronauts on Apollo Lab Station 21. The reports turned into strange warnings. Before all communication was severed, the astronauts relayed garbled messages back to earth claiming they had laid eyes on the "howling face of the sun." The rescue crew sent in to investigate was violently expelled from the station by spacesuits that now contained desiccated astronaut corpses. Visual footage of the incident showed the struggling, ghostly images of tormented figures attached to the corpses, seemingly unable to pull away from the decaying forms.

Even at sketching stage, the linework between the ghostly haloed form and the more solid spacesuit involves a subtle shift in direction.

◀ Thumbnail sketch

The astronaut's hunched posture, a key aspect of the design, is captured in the preparatory drawing. Note that the body's center of gravity is shifted to one side—not right down the middle—so the composition has been carefully lopsided in that direction.

Recreate this....

1 Transfer the thumbnail to a full-size sketch.
2 Finish off the details in pencil and scan in the image.
3 Import into Photoshop and use the "burn" tool set to "highlights" to shade.
4 Highlight with the "dodge" tool set to "midtones."
5 Add colors to a "soft light" layer.
6 Take care not to introduce too much texture to the synthetic materials that make up most of the design.
7 Place a paper or canvas background behind the character artwork.

The final artwork depicts the figure in the space station's artificial gravity setting, but here the corpse floats in a vacuum.

▲ Spacesuit

Note how even in a "weightless" environment the human form inside the bulky, pressurized spacesuit still dictates structure and movement (see pages 33–34). The fit of the garment is quite loose and baggy because the mortal form has largely rotted away.

▲ Value study

Avoid exaggerating technological details on the surface of the suit as large sections must remain gadget-free for heightened visual contrast. Intricate and convoluted features used sparingly will stand out more against the adjacent folds of bare plastic covering.

SEE DECAY PAGES 30–31 PROPS PAGE 37 ANATOMY PAGES 24–29 POSES PAGES 32–35 DETAILS PAGES 48–49

The astronaut's process of transformation provides important visual clues for the final shape of the Wight as the creature erupts from the ravaged human shell.

▲ Props: nebular halo

Futuristic imagery provides some of the inspiration for the simple orb crown that frames the head of the solar-born Apollonian Wight (see page 29).

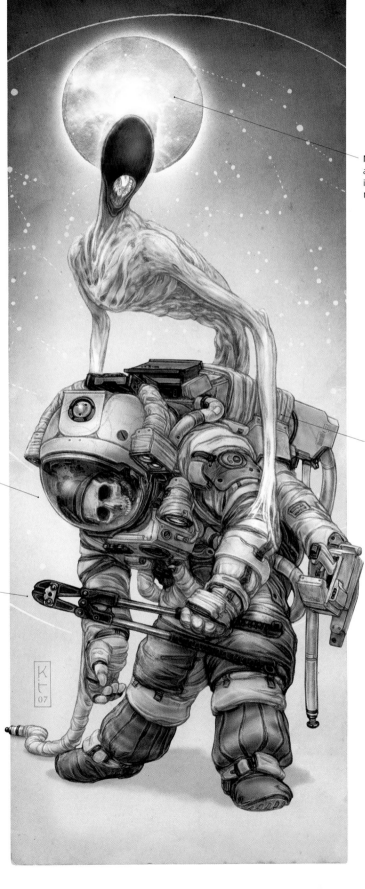

Not only is the halo an interesting visual, it also reminds us of the Wight's origins.

The skull of the astronaut lies flat against the glass of the helmet.

Large cutters are dangerous weapons and allow the Wight to destroy essential life-support systems and dismantle barricades or blocked hatches.

The arms of the Wight merge into the forearms of the host body.

► Finished art

The finished painting results in a somewhat sterile image—especially for an undead monster! The disrepair on the spacesuit works well, but any traces of dirt or organic matter would be out of place here. This incongruity could be weaved in to hint at earlier events or unnerve the viewer with a non-linear storyline (see page 46). The improvised weapon held by the astronaut-host must be something a space explorer would have access to, although this low-tech model is exaggerated to add terror.

Psychopomp

As boatman to the recently deceased, this "soul conductor" from Greek mythology emerges from the swirling mists of the rivers of the underworld to pick up passengers. Standing on the boat prow, he extends a bony hand to collect the coins placed inside the mouths of the deceased as a toll to secure their passage.

Recreate this....

1 Transfer the thumbnail to a full-size sketch on gessoed masonite using scaling grids.
2 Draw a loose background for the final painting and add color, starting with dark, ranging up to light.
3 Similarly, with the figure, add first dark hues, working up to highlights.
4 Use loose brushstrokes for the darker areas. Keep it mysterious as less detail is sometimes better.

▲ Thumbnail sketch

If some of your initial ideas occasionally go too far and miss the essence of the piece, core elements might still be viable. Remember to carry these forward in any reworking of the basic concept. Here, the wings have been removed and the hourglass reduced in scale so it now hangs from the wrist.

▲ ▶ Alternative poses

Identify the kind of linework that best describes your character. Mean characters develop sharp and straight lines; ephemeral characters are best portrayed using swirls and curlicues; graceful beings are brought to life by flowing lines. The enigmatic Psychopomp is rendered in jagged lines that translate into tattered robes and a world-weary personality.

▶ Portrait

Concealing parts of the face from the viewer can be just as effective (if not more so) than a full reveal. Combine shadowy sections with only hints of other areas visible for a very evocative piece.

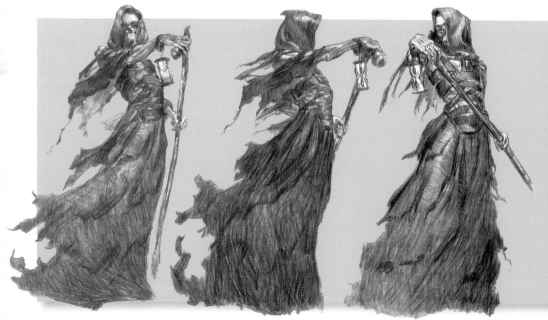

Value studies and rotations

This series of angled rotations represents a 360-degree presentation of the Psychopomp, both in terms of appearance and range of movement. Notice how the gnarled staff, monk's cowl, leather harness, lantern, and flowing robes work well together. These sketches also function as tonal studies in value and shading. Notice how the folds in the cloth and the bony cavities of the skull stand out with the application of light and dark.

SEE DECAY **PAGES 30–31** ANATOMY **PAGES 24–29** POSES **PAGES 32–35** SETTINGS **PAGES 46–47** THE ETHEREAL **PAGE 29**

▲ **Props: hourglass, coins, and staff**

Accessories (see pages 48–49) are every bit as important as costume or setting. Each of these props (see page 37) was chosen carefully with the aim of expanding a different aspect of the creature. The design of the coins echoes its bony frame; the hourglass plays with the idea of expired time; and the staff lends the figure an air of final authority.

▶ **Finished art**

Your character may be brilliant and the aesthetic execution impeccable, but if mood and atmosphere fall short, the whole execution will seem shallow and flat (see pages 40–45). This moody piece is filled with bleak foreboding. The only light source, placed behind the figure, looks as if it is being swallowed up by the surrounding darkness (see pages 27 and 41). All visual details are deliberately kept vague to suggest an apocalyptic-type atmosphere.

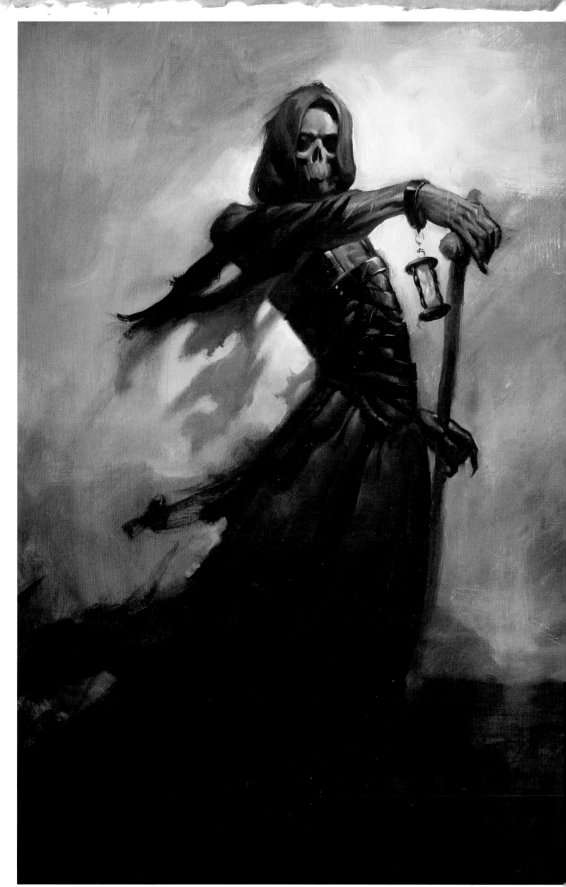

Yokai

In Japanese folklore an object can over time acquire a personality of its own through repeated use. This demonic presence manifests physically as a twisted, half-formed being—at best with motivations incomprehensible to mankind, at worst viciously mad. The Yokai are known to pervert everything they influence and are hostile to humans, killing them and staking their claim to seemingly random spots in the wilderness or along country roads.

▲ Thumbnail sketches

The posture remains unchanged but major parts of the design are revised in the second sketch. The biggest change is the introduction of a lantern that becomes a ghost! The basket has been removed because it clashes with the wicker hat.

▶ Sketch

The balance of elements is tricky because there are three faces at work in this design. The main focus is on the Yokai presence inside the lantern but the eye is also drawn to the caged face of the host and then down to the carved head of the statue. Notice how the traveler's hat completely obscures the face of the host.

If a piece includes two or more faces, the visual hierarchy must be clear cut so they do not compete.

The monk's offering bowl contains a pile of teeth in mockery of religious tradition.

Recreate this....

1 Enlarge the thumbnail to a full-size sketch, including extra details to add interest to the figure.

2 Scan the sketch and import into Photoshop as a separate layer.

3 On a layer beneath the sketch, lay down the main color masses.

4 On the next layer up, use the "dodge" and "burn" tools to sketch in the main highlights and shadows.

5 Ensure that the stylized elements like the swirling clouds are not too heavily shaded.

6 Build up the details on the topmost layer using the Photoshop tools that suit your work best.

Props: monk hat

Although revealing a masked face may take away a sense of mystery, some conceptual risks do pay off. The host's head has been left out here so the hat is empty except for the swirling smoke wisps that emanate from the lantern.

Props: samurai sword

Artifact spirits called *tsukumogami* control objects that are one hundred years old or older, making them alive and "aware." In this design, there are two ghosts at work. The lantern ghost is the primary spirit, but it also directs the body of the host. Samurai confronted by the Yokai are taken by surprise when another ancient and deadly spirit also springs from the sheath of the sword!

SEE ANATOMY **PAGES 24–29** DECAY **PAGES 30–31** POSES **PAGES 32–35** DETAILS **PAGES 48–49** PROPS **PAGE 37**

◀ **Rear view**

The physical appearance of the host is made clear when the figure is viewed from behind standing upright (see pages 36–39). The distinct raised sandals—designed to keep feet dry—are best viewed from this position. The character must be able to balance on them properly as the feet are close together.

▶ **Finished art**

The distinct color scheme (see page 28) and value range work well with the unusual subject. Although the influence of Japanese Ukiyo-e prints (see page 14) has been a subtle undercurrent all along, this key visual direction becomes apparent in the final painting.

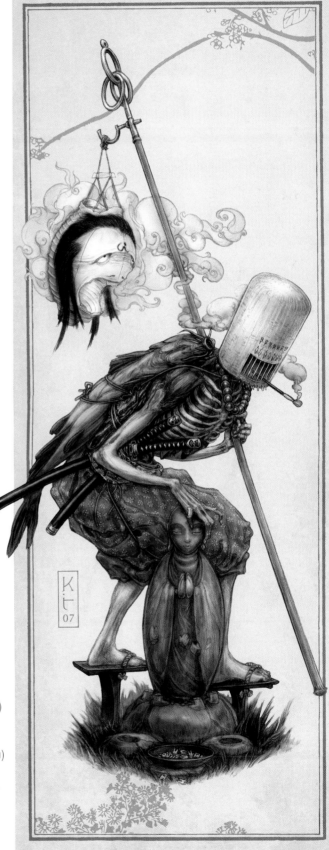

Wraith

This spirit appears as an omen and returns to avenge its own death. When the remains of the deceased have been scattered or separated, the soul cannot find peace, and manifestations of unrest haunt each body part. The more scattered and separated, the stronger the manifestation, which can only be appeased by reuniting the pieces.

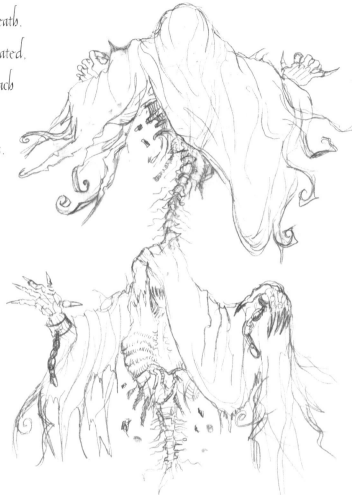

An indication of the background is included in this side view (the viewpoint used in the final artwork). The backdrop serves the creature, and any realignments will depend on the final pose.

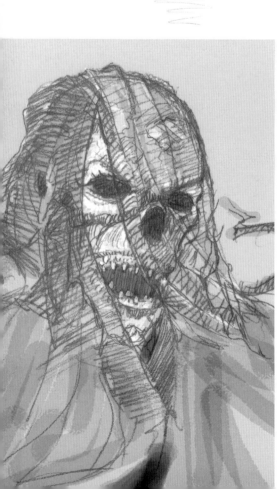

◀ Portrait
This detailed face study is fleshier than the final version. The main features are empty sockets, a sunken nasal cavity, and a razor-sharp set of teeth.

▲ Thumbnail sketches
Loose forms can produce great results, but the success of a character hinges on details adapted from a short description or story (see page 46). The Wraith's presence is determined by the distance of its scattered body parts: this translates into a nautical theme with the sea as a vast, empty grave. The empty ankle manacles and exposed spinal column hint at its disembodied nature.

▶ Props: shackles
A quick sketch study of manacles helps establish the style and time period involved. In fantasy art, you can experiment with wide time spans: for example, the Wraith could be wearing fifteenth-century shackles as he now wanders in the seventeenth century (see page 37)!

Recreate this....

1 Draw the final character study in pencil.
2 Transfer the image to the board.
3 Paint onto the board, blocking in the main color. Allow to dry.
4 Scan in the preliminary painting and import into Photoshop.
5 Paint and blend in the selective glazes, add highlights, and adjust the color.
6 Clean up any rough edges.

SEE ATMOSPHERE PAGES 40–45 DECAY PAGES 30–31 ANATOMY PAGES 24–29 THE ETHEREAL PAGE 29

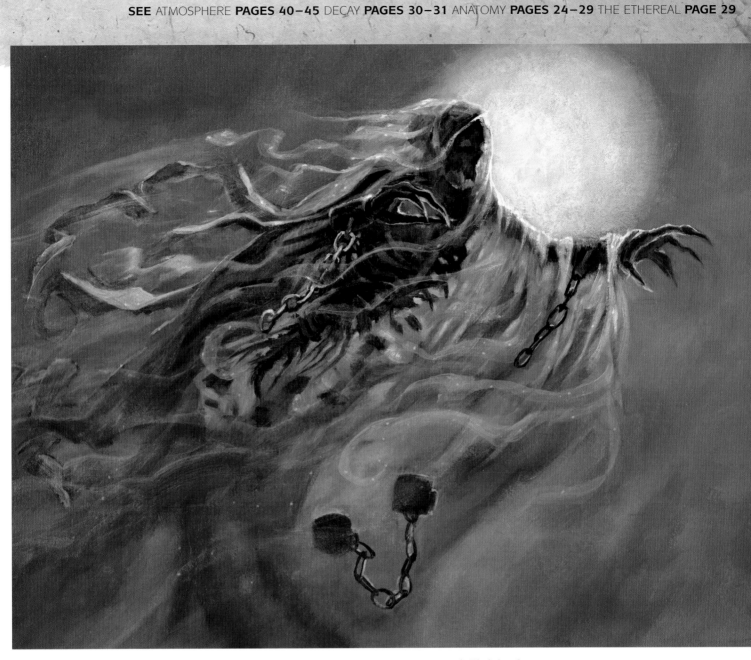

▶ Value study

Initial touches of shading bring out the Wraith's skeletal form underneath the wispy cloth. As you do further studies, let your design evolve. Changes might be spontaneous, but make sure you have a full grasp of where the new direction is taking your art.

▲ Finished art

In the final painting, the Wraith floats eerily in a chilly, moonlit setting with the backlighting and translucency of the cloth conveying its bones in silhouette (see page 41). Notice how the final painting is a close match to the initial sketches.

The lighting is left inconsistent in between the rotations (see pages 36–39) until the final pose is chosen—otherwise this would mean having to realign the moon behind the figure with each new successive view. The sea is hinted at as a dark mass with the full moon reflecting on the water's surface.

Civatateo

In Aztec mythology, noblewomen who died during childbirth were known as the Civatateo. Believed to be servants of the gods, these pregnant Mexican vampires would accompany warriors—hovering in midair above them—into battle, spurring them to spill the blood of their enemies. In exchange for every battle won, these ghastly creatures demanded the life of a newborn child.

▲ Portrait

If using recognizable cultural associations, do your research thoroughly. In this design, a small Aztec female statue is the central source of inspiration (see page 12). Shadows economically applied to basic linework quickly create an evocative face. Notice how all visual references—from the crown of skulls to the central nasal cavity—are rendered carefully to work with the tale.

▶ Thumbnail sketches

Once the initial drawing has been scaled down, a feathered headdress is introduced. A better understanding of the creature's entire form is made possible by this simple change in scale (see pages 22–23). Even when working in pure line, silhouette is a major consideration. Shape makes an immediate impression so it must look right. Explore different angles of the same thumbnail even if you think you are satisfied with your first design. Revisiting an image only strengthens your understanding of the final piece and allows you to explore other ideas (see page 36–39).

Recreate this....

1 Transfer the thumbnail to a full-size sketch, freehand or by grid method directly onto gessoed masonite.

2 Draw a loose background for the final painting, gradually building up gradients.

3 To the main figure, add dark hues for the full value range, working up to highlights.

Value studies and rotations

Controlled drawings such as rotations and value sketches are useful in developing a concrete understanding of detail and form. Use shading and value to flesh out the smaller details, increase visual interest, and bring out a defined identity. The details you put in will help tell a story. Notice the breasts ending in infant body parts or skulls, the swollen belly, feathered headpiece, and patterned skirt (see pages 48–49). During the rotations, keep the alignment of the body, especially the back, consistent.

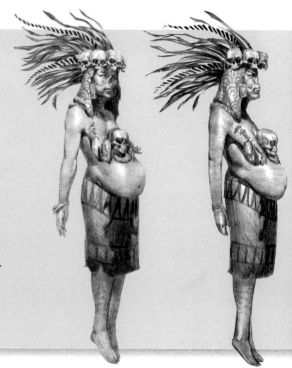

SEE STORYLINE **PAGE 46** ATMOSPHERE **PAGES 40–45** COLORS **PAGES 28** CREEP FACTOR **PAGE 31** POSES **PAGE 32–35**

► Finished art

In the final painting, push for that last bit of personality to shine through. A murky color scheme is chosen to reflect an oppressive atmosphere of rage and decay (see page 28). The cool tones of the Civatateo's skin convey dead flesh convincingly (see page 54). Instead of showing blood directly, the deep red of the skirt and pattern on the cloth headdress connect with the gruesome sacrificial elements in the narrative. The open-mouthed, silently screaming face is emotionally charged, offering possible correlations with an agonizing childbirth.

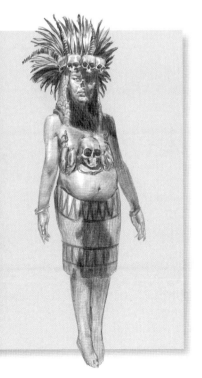

Saracen Ghast

At the times of the Crusades, atrocity matched atrocity and travelers hoped to suffer nothing more than the moaning ghosts of massacred victims of war. As more pilgrims were found slaughtered, the clergy admitted that a raiding force of Ghasts were haunting supply lines. Tasked with the threat, the Knights Templar remained intentionally lax as pilgrims continued to fall victim to the Ghasts.

Two undead creatures—horse and rider—are being depicted here.

▲ **Thumbnail sketch**
Maintaining the horse's balance was a major challenge in establishing the general silhouette of the design. The problem was compounded by presenting the creature in motion. Keep the center of balance inclined toward the direction of movement with the rider's posture compensating for any resulting imbalances (see pages 38–39).

▲ **Sketch**
The posture of the horse is more carefully rendered than the rest of the design. Notice that only the front of it remains. A loose approach to the mount's pose adds movement but its musculature must be carefully handled. An even-handed treatment is uniquely important to this design.

▼ **Portrait**
This angled sketch of the Saracen's swathed head without a helmet on provides an intriguing view. The face is covered and the eyes are striking. Much of the character's supernatural origin is expressed through the intensity of its glare (see page 31).

▶ **Props: scimitar**
The sword—depicted in its sheath in the finished art—is a heavily decorated item. Although not drawn from its scabbard, it remains a dominant aspect of the costume. Relative scale is important in keeping a check on whether items like weapons are interacting successfully with the character.

Recreate this....
1 Prepare sketches of the rider and mount from different angles to better understand the forms involved.
2 Select your favorite angle and work it up into a full-sized sketch.
3 Scan the sketch and import into Photoshop as a new layer.
4 Add the main color masses on a separate layer.
5 Add shading with the "burn" tool set to "highlights" and define the patterns on the coat of the steed.
6 Define the finer details and highlights of the topmost layer.

SEE ANATOMY **PAGES 24–29** DECAY **PAGES 30–31** POSES **PAGES 32–35** DETAILS **PAGES 48–49** PROPS **PAGE 37**

▶**Finished art**
The final painting is richly
patterned and decorated.
Although somewhat
damaged and disheveled
from its violent past, the
Ghast's exotic costume with
its plates and chainmail
retains its elaborate
trimmings and tailoring.
A potential conflict of
focus between mount and
rider is resolved by the rich
colors (see page 28) and
sumptuous details adorning
the Ghast.

Index

Credits

Quarto would like to thank and acknowledge the following for supplying illustrations and photographs:

tl = top left; tr = top right

12tl Courtesy of Alamy
12tr Courtesy of Art Archive
12bl Courtesy of Art Archive
12br Courtesy of Bridgeman Art Library
13 Courtesy of Bridgeman Art Library
14 Film stills: courtesy of Kobal; Japanese woodcuts: courtesy of Bridgeman Art Library
15 Video games: courtesy of Konami Digital Entertainment
50tr Courtesy of Bridgeman Art Library; b/w photos: courtesy of Getty Images

The following artists contributed to this book:

Ralph Horsley
Paul Gerrard
Anne Stokes
Efram Palacios
Malcolm Brown
Lucas Graciano
Scott Purdy
Jon Hodgson
Matt Dixon
Karl Christensen
Ricky Sardhina
Erik Gist
Kari Christensen